PROFESSIONAL SECRETS OF NATURE PHOTOGRAPHY

ESSENTIAL SKILLS FOR PHOTOGRAPHING OUTDOORS

Judy Holmes

AMHERST MEDIA, INC. ■ BUFFALO, NY

Dedication and Acknowledgments

For my husband, Jim, the greatest friend anyone could have.

To my photo friends Elaine Bachelder, Greg Baer, Tracy Gordy and Bob Grant.

Special thanks to Michelle Perkins, Senior Editor at Amherst Media, and to all who reviewed this manuscript offering suggestions for improvement, especially Mike Kirk, Jim Langdon, Lloyd Holmes, and Jane Davidson.

Copyright ©2000 by Judy Holmes
All photographs by Judy Holmes, except page 120 by Greg Baer.
All rights reserved.

Published by:
Amherst Media, Inc.
P.O. Box 586
Buffalo, N.Y. 14226
Fax: 716-874-4508
www.AmherstMediaInc.com

Publisher: Craig Alesse
Senior Editor/Project Manager: Michelle Perkins
Assistant Editor: Matthew A. Kreib

ISBN: 1-58428-021-2
Library of Congress Card Catalog Number: 99-76255

Printed in Korea.
10 9 8 7 6 5 4 3 2 1

TABLE OF CONTENTS

INTRODUCTION

If you produce great pictures some of the time but not reliably, this is the book for you. On these pages, I'll describe how to take your pictures or slides from the ordinary to the unusual – consistently and without spending a nickel or taking a year off from your day job.

The material presented here is distilled from twenty years in the field, including ten years of reviewing hundreds of photographers' images, teaching thousands of workshop participants, working with a stock agency which gives immediate feedback, and listening to innumerable questions, problems, and confused queries about making satisfying pictures.

My conclusions are simple ones. There are only a few things that misfire in our images: the *exposure* is not what we intended; the *composition* lacks expression, or our *equipment* didn't perform the way we expected. This book addresses those three issues and gives practical, immediately useful information to take your photography to the next level, regardless of where you are today.

Each section stands alone and can be read in any order. Terms that may need a little extra explanation are printed in **bold** and are fully defined in the glossary at the end of the book.

You don't need to read the whole book to gain useful knowledge and increase the quality your images right away. Where would you like to see the most improvement? Read parts of that topic first, and refresh your memory just before a photo excursion to the backyard or to Bangkok.

Memorize only a few points for the outing and work on those. Most of us get on location and want to work on several techniques, but our minds go blank. Avoid this by choosing one topic, such as exposure, and one subsection like "fill flash," and practice that. I have a "rule of threes." I can work *at most* on two exposure techniques and one composition technique or vice versa, but any more than that and I'm not enjoying the scene and the process. Creativity is released from a relaxed mind, not a stressed one.

◁ The three keys to improving your photography are mastering exposure, composition, and your equipment.

EXPOSURE

If **exposure** accounts for nearly half the problems photographers experience with their images, it is also the half we least want to deal with. It is more technical in nature, seems to be a battle with the camera for each spectacularly-lit scene, and appears hit or miss even in the best conditions. This chapter will get to the root of the problem to put you firmly in control of your camera's **meter**, and your ability to judge light within a half stop from brightly sunlit afternoons to overcast days. With these skills, you'll be able to duplicate your best exposures, over and over again.

◅ If exposure accounts for nearly half the problems photographers experience with their images, it is also the half we least want to deal with.

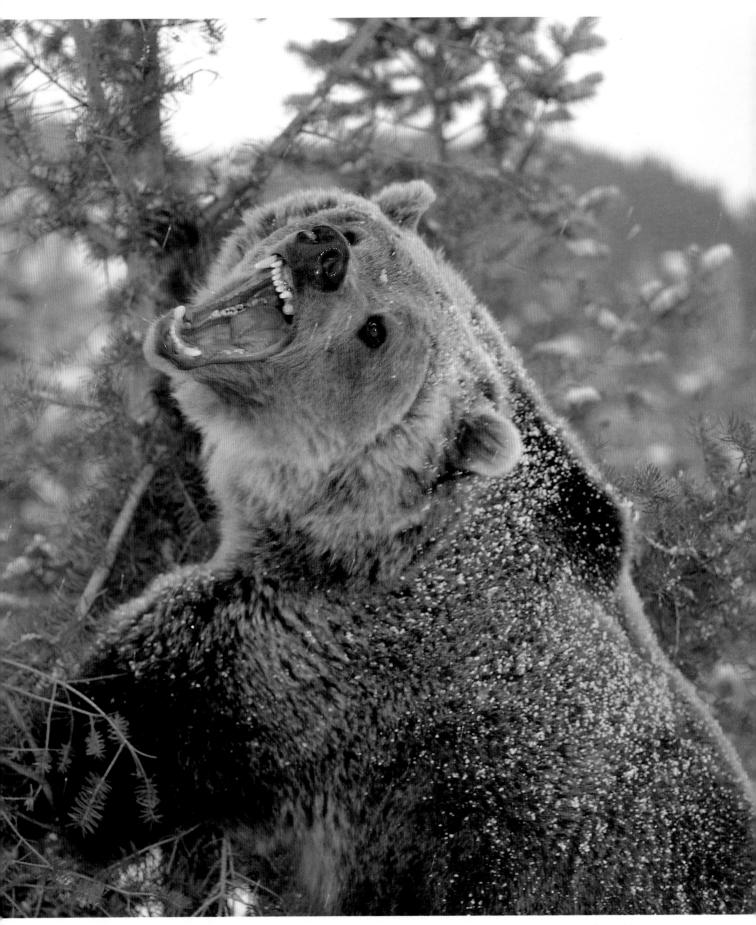

▲ Sometimes there's only one chance for a great exposure. Subject: Cocoa, a wildlife model, photographed outside Bozeman, Montana.

Understanding Your In-Camera Meter

Let's get right to it: unless you can dependably expose your pictures for the effect you intended, roll after roll, you have not mastered an understanding of your in-camera or hand held **light meter** and how it functions. **Exposure** baffles most amateurs and many professionals. If the lighting is the least bit unusual, there's nervousness as to whether we "got" the shot. Because of this, photographers needlessly make more exposures than necessary – they **bracket** from uncertainty, not for creativity.

Even if you are an experienced photographer, by refreshing yourself on this "craft" aspect of photography (I think of composition as the "art"), you will bring home more winners and avoid blasting through rolls of film on guesswork.

The goal of photography is to recreate on film with confidence and regularity those beautiful scenes in front of your eyes. Sure, luck will play a role in bringing it all together for that once-in-a-blue-moon magical moment, but for everyday experiences, success has everything to do with skillful control.

Every internal camera **meter** has a "reflected" component. It measures the light bouncing off, or reflecting off, the subject. The metering mechanism in the camera measures the light reflected back to it, usually by means of a large, round, center weighted pattern, or a small circular "spot" in the center (you choose the one you want for the situation). The metering arrangement can also be an almost infinite combination of patterns, which you'll find on the more sophisticated cameras. Yet from the simplest point and shoot to the most advanced **SLR**, all meters share the reflected property and thus all meters share two other major similarities: they work well under average lighting condi-tions, but have a difficult time with extreme (very light or dark) situations.

The in-camera meter works well when the scene exhibits an "average" **reflectance**, either with one predominant "average toned" subject (as below) or a combination of subjects in the scene, resulting in average reflectance overall.

For example, when we look at a scene with our eyes, we might see

∨ The in-camera meter works well when the scene exhibits an "average" reflectance, such as these oystercatcher eggs against a gray background. Location: Inside Passage, Alaska.

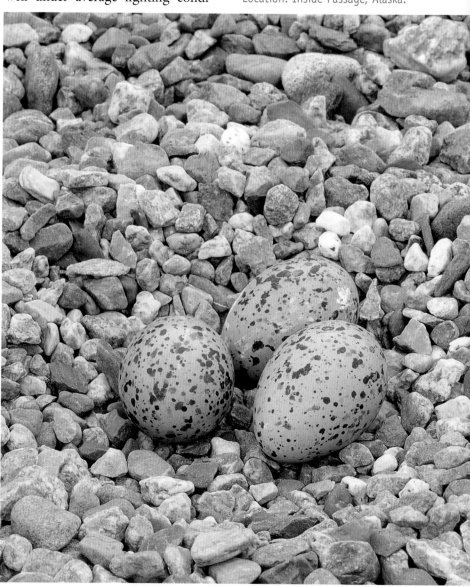

A The in-camera meter works well when a combination of subjects results in average reflectance overall. View: The Riffelsee and the Matterhorn, above Zermatt, Switzerland.

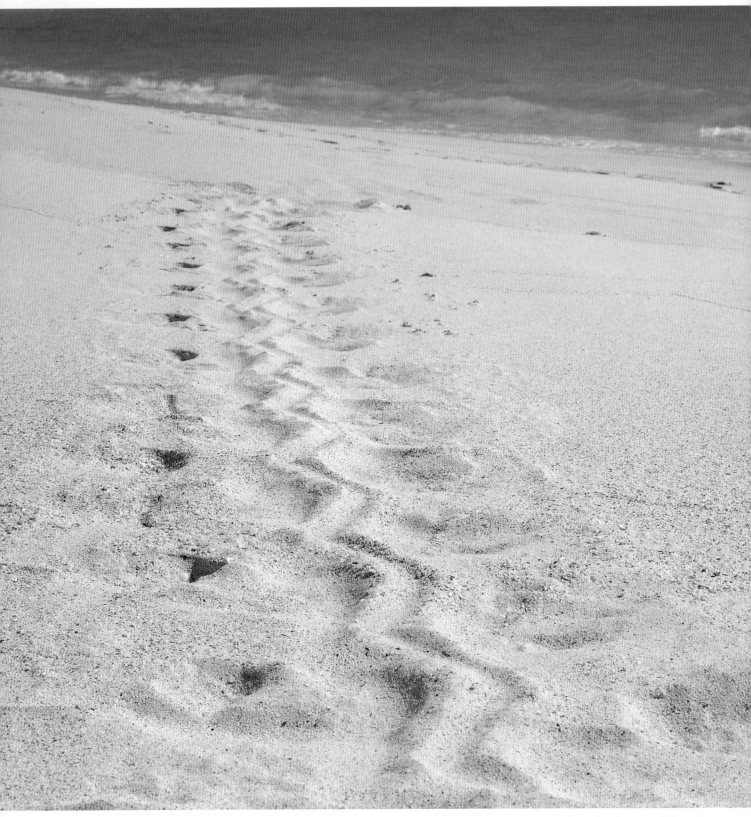

▲ Just like these turtle tracks in the sand, many of our favorite and unusual subjects do not reflect the "average." Location: Galapagos Islands.

HOW YOUR EYES SEE A SCENE...

| Very dark tones, almost black: deep shadows, a very dark sweater, animal, or monument | A charcoal gray or similar darker than medium tone, such as burgundy red, navy blue, forest green, deep mustard yellow | Medium tones such as kelly green, royal blue, cardinal red, light slate gray, banana yellow, khaki brown, lilac | Lighter than medium tones: mint green, pale yellow, pink, robin's egg blue, beige | Very light tones such as pale pink, off white, sand, snow |

HOW YOUR IN-CAMERA METER SEES A SCENE...

| It's a big black hole in here – may reflect only 5% back to the meter | This is significantly darker than a medium tone – reflects perhaps 10% | The meter works best with scenes in this middle tone range – about 18% reflectance | Reflectance is somewhere around 25-50% - quite bright | High reflectance glare or snow or sand – perhaps 85% of the light is reflected back to the meter |

The meter wants to keep exposing dark subjects to bring the average reflectance up to 18%.

The meter works to attain this reflectance; perfect if your subjects are a medium tone.

The meter wants to decrease exposure to bring the light subject into the average tonal range.

the scene as being made up of components as listed in the diagram above.

Scenes with colors averaging out to the middle box (medium tones) expose well on film because they reflect about 18% of the light that hits them – the same reflectance the camera meter is balanced to match. Why is the meter built to measure a middle tone? Camera manufacturers analyzed millions of amateur pictures and found the average composition contained elements such as grass, people, and some sky. The average reflectance came out close to 18%. Thus, this is what your camera meter thinks you want to average out to in all your pictures.

However, this is often not the desired result. Our favorite subjects are usually those without a medium tone anywhere – a skyline at night,

snow piled deep in the backyard, a black cat, shells on a beach, and so on.

This brings us to the second major similarity between all in camera meters: the camera meter has a difficult time if a scene does not reflect a middle tone. There are three major categories of scenes without average reflectance.

1. High Reflectance Scenes
In high reflectance scenes, such as snow, a beach, or glare on the water, the camera senses greater reflectance than the "average" – perhaps as much as 80-90%. The meter will simply tone the brightness down to 18% (its average) suggesting an exposure that is up to three stops under what the correct one would be. This is why snow scenes can look a dingy gray, not white. Any scenes that are highly reflective will be

underexposed, sometimes almost to silhouettes. Other examples with which the meter has problems are fog or an overall bright, overcast sky when the sky is included in the frame, and light colored clothing and animals.

An easy way to remember how the camera's meter works in highly reflective situations is to think what happens to your eyes when confronted with a bright scene. Your pupil "closes down" to let less light in and minimize eyestrain.

When the camera meter does this, it shuts off exposure too soon, thus not allowing enough time to fully make your whites white. The light tones are only exposed long enough to turn grayish – a medium tone. Above, you can see how the camera "sees," as opposed to how your eyes see.

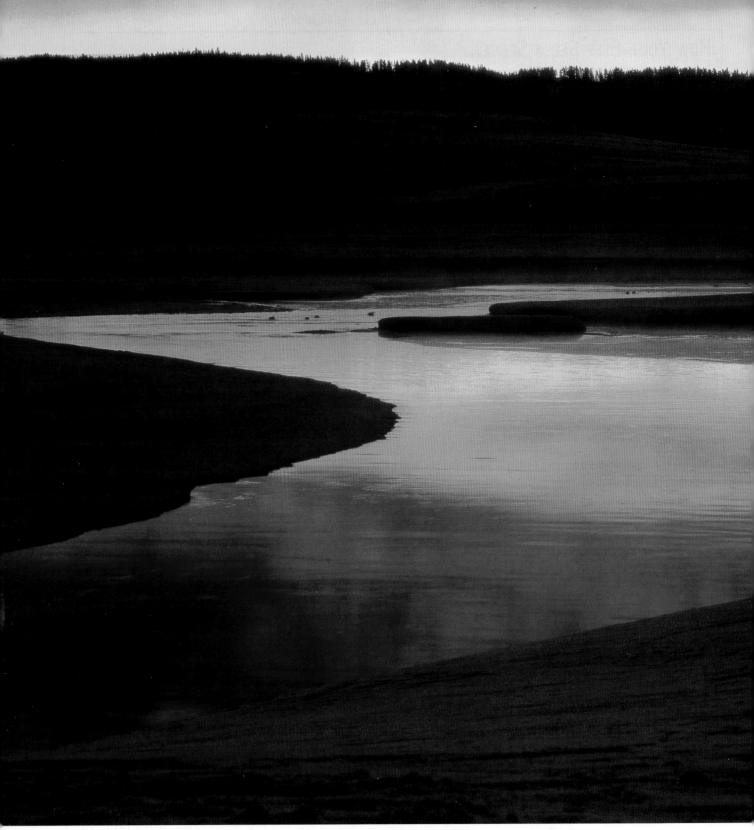

A This scene is *highly reflective* on the water, *low in reflectance* in the background tree area, and *high in contrast* between the water and shoreline. Learning where to take meter readings and how to compensate for them will give you better results consistently, no matter how challenging the scene. To keep rich tones in the water, yet show some detail in the background, I took a reading off the brightest area of the river and opened up half a stop. Location: Alum Creek in Hayden Valley, Yellowstone National Park.

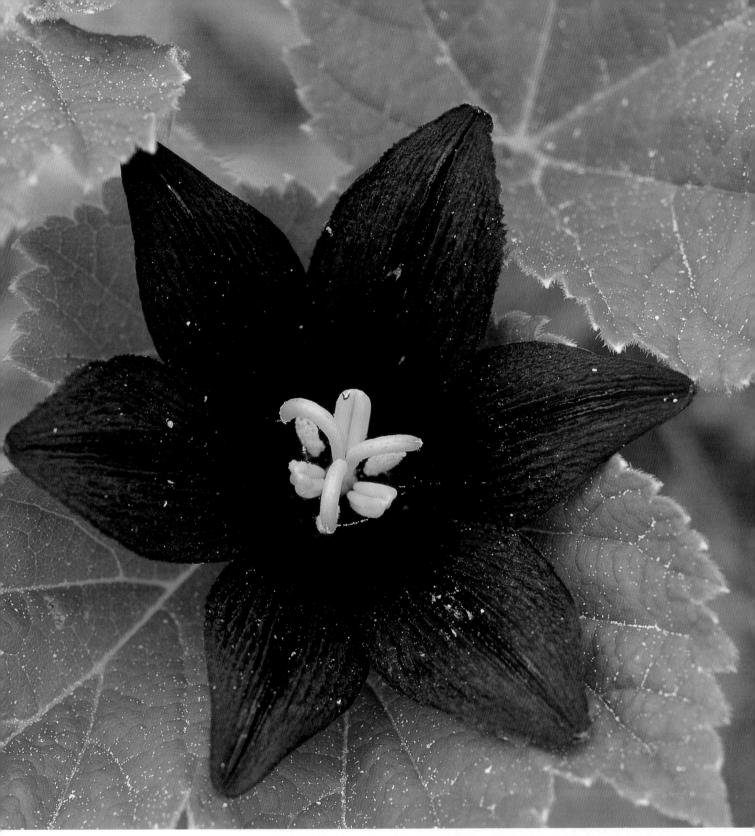

In any scene where the camera cannot find a middle tone, it will have some prob- Λ
lems. The meter exposes the subject it finds predominant for a medium tone. This
chocolate lily is an example of a lower than average reflectance subject we will work
through in the next section. Location: Inside Passage, Alaska.

2. Low Reflectance Scenes

With dark daylight subjects (such as the lily on the previous page or night images such as the covered bridge on page 16), the meter receives little reflectance bouncing back from the scene. It therefore suggests a long exposure to turn these dark tones "average," which results in an overall muddy medium gray or brown tone – not at all what you wanted. Unless the meter has an average tone to measure, we have to fool it or compensate to get a good exposure. We will work through the lily example in the next section.

3. High Contrast Scenes

The third major category the reflected meter has trouble with is high contrast scenes such as a white lighthouse against a dark sky or a dark flower against a foggy background. In any scene where the camera cannot find a middle tone, it will render as medium toned the subject it finds predominant in the middle of the frame where you point the camera. One of the most common high contrast situations involves people backlit against a bright background (on a beach or in front of a bright window, for example). I'll show how to compensate in the next section, using the example of the erupting geyser on page 19.

No matter how sophisticated the meter, it still measures reflected light, and what it tells you is not necessarily accurate for what you want to expose. The farther your subject is from the middle tone, the more you will want to use your own judgment. Whether you spend a thousand dollars on a state of the art system or fifty dollars on a point and shoot camera, you will still need to compensate in "not average" conditions.

Adjusting Exposure

Fixing the problem becomes easy once you review the chart below, which shows you in what direction to compensate from the meter reading.

In *high reflectance* situations, the scene lacks medium tones, or only has a small patch of "average." Such a situation occurred with this foggy day in Switzerland (opposite), where the small patch of grass in the foreground wasn't large enough to give the meter an adequate "average fix." The meter therefore saw an overall "bright" situation and suggested an exposure to tone the light down. If we followed this advice, our image would be **underexposed** – the very light fog rendered a medium gray not nearly as dramatic as the scene we saw. Several options are available

to us to increase the exposure to the desired level.

When photographing with a completely automatic camera, I try to find a medium-toned subject (like a larger patch of grass) about the same distance from me as the subject I wish to photograph. Then I press halfway down on the shutter button. This will likely lock in both focusing and metering, so I'll take care in choosing the distance wisely. I'll recompose and press the shutter all the way to take the picture. If the grass is exposed correctly as a middle tone, then the light areas will be exposed correctly, and so will the dark areas.

With a manual override SLR (or an automatic camera with an exposure compensation dial), there are three easy options to correct high reflectance scenes.

The first solution is to hold a **gray card** in front of you, filling two thirds of the frame, and take a reading off it. Then, it is a simple matter of adjusting your camera settings accordingly. A gray card is simply an 18% reflectance card, so reading off it ensures that the exposure is correctly balanced. Tilting the card at the same angle as your subject

HOW TO COMPENSATE FROM THE METER READING...

Deep tones – charcoal gray, black, deep shadows	Darker than medium tones such as chocolate brown, forest green, navy blue, burgundy red	Medium tones such as kelly green, royal blue, cardinal red, slate gray, banana yellow, khaki brown, lilac	Lighter than medium tones: mint green, pale yellow, pink, robin's egg blue	Very light tones such as pale pink, light beige, off white, sand, snow.
-2	-1	THE METER EXPOSED FOR THIS.	+1	+2

Decrease exposure when your primary subject falls into this range. Starting points (in stops) are given above.

THE METER EXPOSED FOR THIS.

Increase exposure when your primary subject is lighter than a medium tone.

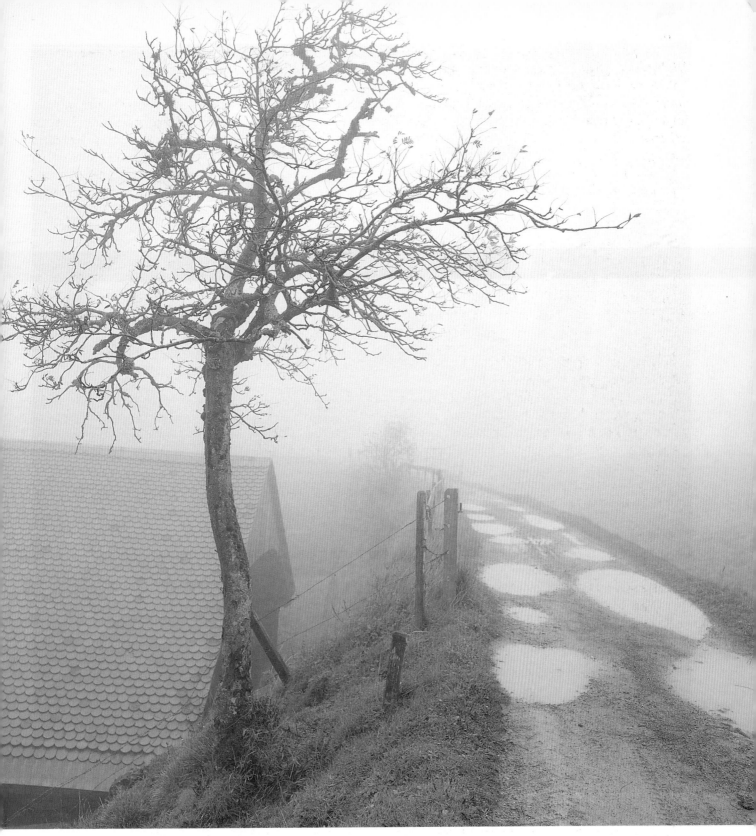

A The small patch of grass in the foreground isn't large enough to give the meter an adequate "average fix." It will therefore see an overall bright situation and suggest an exposure to tone the light down. This would result in an underexposed image with the very light fog reproducing as a medium gray – not nearly as dramatic as the scene we saw. This image was made while hiking on the Rigi between Staffel and First, in Switzerland.

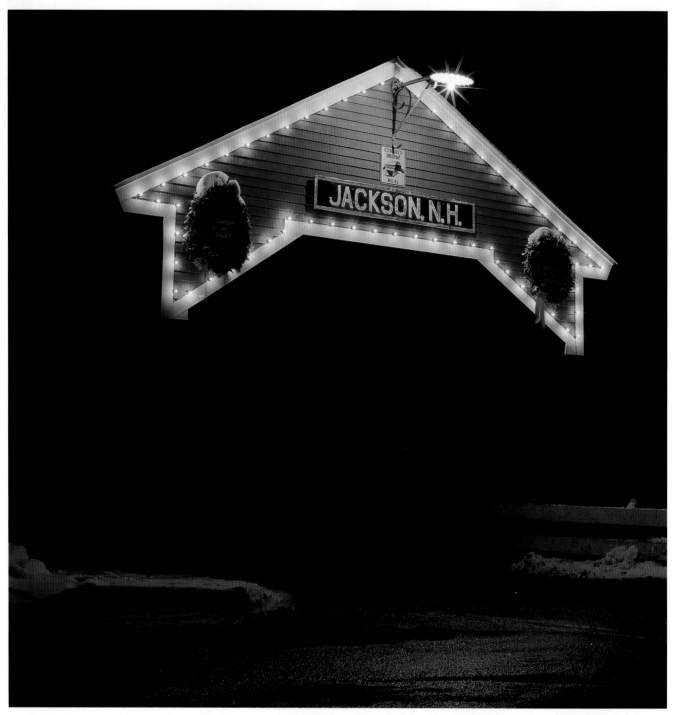

▲ This night image of the Jackson Covered Bridge in New Hampshire is mostly low reflectance with a patch of brightness – overall, it is considerably darker than a medium tone, but if a reading is taken to include the brightest area, the result will be a good first try. This exposure was eight seconds at f/11, on ISO 100 film. Consult the guides on pages 17 and 19 for more information.

(keep the two parallel) will yield the most accurate result.

The second option is to take a hand-held **incident meter** reading. This works well if you are in the same light as the subject. An incident meter measures the light falling on the subject, not bouncing off it. It therefore works well regardless of the color or reflectance value in the scene. However, you must remember to tilt the dome at the same angle as the light falling on the subject. A common mistake is to hold the meter so the dome is facing straight up toward the sky. Unless the subject is flat on the ground, the reading will be worthless. Also, the meter must be in the same light as the subject, which can be impractical for distant scenics.

Last, if a gray card, a medium-toned subject, or an incident meter are unavailable, adjust the exposure yourself. The way many professionals

adjust their settings is based on experience, such as opening up to 2.5 stops from the meter reading for snow, a stop for fog, and so on, and fine tuning from there. With practice, you will be adjusting first based on your own judgment, using the metering aids as a second opinion. See page 14 for estimates.

A *low reflectance* scene is predominantly darker than average. Familiar subjects are shaded buildings or monuments, black cats, people in dark clothing, and most night scenes. Dark subjects in daylight cause the in-camera meter to overexpose the scene to bring it in line with medium tones. The correction for the automatic camera is to find a medium tone elsewhere in the area and meter for that. You can take readings off a friend who may be wearing khakis, a washed denim jacket, etc. – any medium tone will work.

For a manual camera, use an incident meter, gray card, or estimate exposure based on how far from medium toned the subject is. See the example on the next page. Many photographers take a reading off their outstretched palm. Because caucasian skin is lighter than 18% average, they compensate by opening up (increasing exposure) one stop.

For night scenes with an automatic camera, choices are somewhat limited. Flash is not an option since the night-lights are more than ten feet away and flashing the scene would defeat the purpose anyway.

One option is to load **ISO** 800 or ISO 1000 film. You can also try pointing your camera at the brightest part of the scene to fool the meter into thinking there is more light present than there is (see the covered bridge on the opposite page). You may achieve a somewhat dark image, but some of the evening lights may remain a rich tone.

For night scenes with a manual camera, your camera may meter exposures up to thirty seconds long, but I find practice to be the best teacher – though some rules of thumb are good starting points. Experience will ultimately prove most accurate for a particular camera and subject, but the results will generally be a refining of the guidelines presented on page 19. Since night scenes are mostly "unmetered," let's leave further discussion of this topic for the next section.

< For night scenes with a manual camera, I find practice to be the best teacher – though some rules of thumb are good starting points.

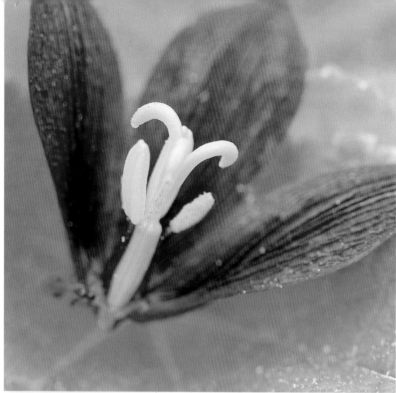

◁ Frame 1. The dark lily reflects considerably less light back to the meter than "average," which results in a longer exposure than necessary. This makes the lily look medium brown on film – not deep chocolate.

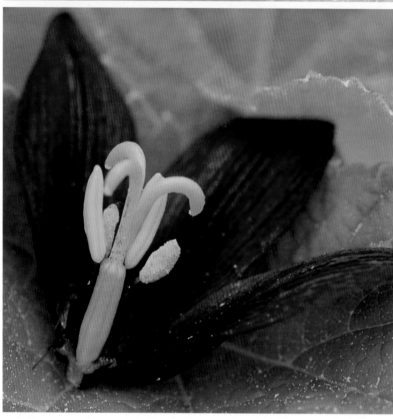

◁ Frame 2. I found a medium tone in the green leaves and took a reading off this area. Once I had the correct reading, I could either lock it in and recompose, or put the camera on "manual," set the lens and aperture, then recompose. When the medium tone is registered correctly, so are all the other areas.

High Contrast

Let's take another look at our low **reflectance** chocolate lily and how to **expose** it well.

In the first image (frame 1), I pointed the meter at the center of the subject, hoping the camera's **center weighted metering** pattern would also pick up the green leaves in the flower. It didn't work – the picture is **overexposed**, because the overall reflectance is much less than average and the camera compensated with a longer than necessary exposure. The deep chocolate color became a washed-out brown. (See page 11 for diagram of this concept.)

In the second image, I metered on the medium tone leaves without the lily. As a result of metering off the leaves, the medium tones are accurate, which means the light and dark tones are also recorded faithfully.

I could also have focused on the flower, inserted a **gray card** between

the lens and subject and taken a correct reading that way. The 18% reflectance of the gray card and the reflectance of the green leaves is just about the same.

In a high **contrast** scene like the one below, with a very light or dark dominant area against a strikingly different background, the meter searches for a middle tone. Making a correct exposure is easier than you think. First, decide what area you want to expose for – is it the plume of hot air and water? The ground around the geyser? The sky?

I chose the erupting water and gasses against the sunrise, not caring about the sunrise or the ground. With this in mind, I pointed the meter barely to the left of the sunny area to guarantee the shortest exposure time. Why? A short exposure would render everything but the bright areas underexposed, and therefore cause the silhouette I wanted. Notice that I did not point the meter at the round ball of the sun – that would shut down the meter too much and result in an overall dark image with no light tones.

Had I pointed the meter farther to the left of the eruption, I would have given the meter a darker area to read from. This would have resulted in a longer exposure with more detail on the ground, and less drama in the sky and eruption. An **incident light meter**, in this case, would have been of little help. I was in much lower light that the action, and thus my reading would have indicated a long exposure – overexposing almost everything.

In summary, when dealing with a high contrast situation, take a moment to think what tones are most important, consider how the meter will read those tones, and use this to your advantage. Sometimes I take several readings throughout the scene and choose the one I think will expose the scene in the way I want.

⋁ The geyser erupting at sunrise is a good example of a high contrast scene. Location: Castle Geyser, Upper Geyser Basin, Yellowstone.

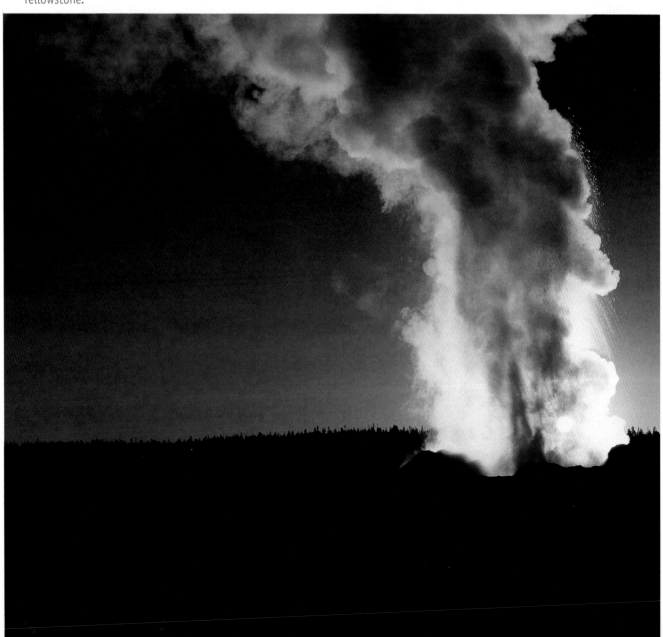

Using Flash

Another option for correctly exposing in *high contrast* situations is to use a flash. Almost every photographer I know has to remind himself to use flash more often in daylight situations. The meter usually won't call for it if it finds enough light present in the rest of the scene.

The "person against a bright background" is a familiar situation. The **meter** is overwhelmed with the background light, even though the subject fills about half the frame. As a result, the meter will suggest a short exposure that will underexpose the subject in order not to overexpose the background!

Getting around the problem is simple. Pop up the flash or add your own separate flash, and set it to "fill" for an automatic blast of fill-in foreground light. Or, set your sophisticated flash to "-1" or "-2" which simply stands for "less one" or "less two" stops of flash from the full flash position.

Fill Flash vs. Full Flash

The difference between **fill flash** and **full flash** is this: the flash is the subject's main light when you use "1/1" or "full flash," whereas the room, daylight, or other **available light** is the main light with fill flash.

▲ Although the person fills more than half the frame, the meter is overwhelmed by the bright background and suggests an exposure that will underexpose the subject.

Another way to look at full flash is that it ignores the daylight, room light, or night **ambient light** when it's given equal billing with the lens aperture: the flash is in charge. The shutter speed only determines how much of the ambient light (the light around the subject) comes through.

Full Flash

If you desire the flash to be your main light, match the flash to your lens aperture. If you set your aperture to f/8 for example, your flash would be on f/8, or "full" or "1/1" on your flash dial. Check your flash or camera manual for its settings.

Now choose the shutter speed. At a slower shutter speed, such as 1/30th of a second, background light will be evident. A faster shutter speed, such as 1/125th of a second and faster, will black out the background. This is great if your scene has distractions or hot spots behind the subject. A caveat: not all cameras

A Getting around the problem is as easy as using flash for an automatic blast of fill-in foreground light.

less than 1/1, the flash will fill in shadow areas but not contribute to the correct overall exposure for the scene.

Here's an example. It's a bright sunny day, and I'm shooting with the **Sunny 16** rule (see page 32). My subject, a skier, is not front lit, but backlit. His shady face will be underexposed with an exposure of $1/125^{th}$ at f/16. Without flash, I would have to increase my **exposure** two stops (from f/16 to f/8) to correctly expose his shady face. What would this do to the rest of the scene? It would overexpose it by two stops. I have two choices for a correct exposure for both the foreground and background.

First, I could move in for a tight portrait of the skier and eliminate the background all together. If I adjust the exposure to $1/125^{th}$ of a second at f/8, it will be on the money.

But what if I really want the skier and the background, both perfectly exposed? Our friend fill flash is the answer.

For this second option, set your manual camera for the Sunny 16 rule. This means you are setting the correct exposure for the bright light of day – the **ambient light**. Now add or pop up the flash. Notice I emphasize exposing first for the main light (which is sun light) and then adding fill light with the flash. Basically, you want to set the correct exposure for a sunny day, and then fine-tune the exposure, using fill flash, for a shady subject.

But how should you set the flash? Set the flash to -1 (one stop less than full flash) if the subject is deeply in shadows. Anything between -1/4 stop and -1 stop will fill in the shadow areas almost completely. It may even look unnaturally lit and flat, so practice will determine the appropriate

allow a variety of "synch" speeds with the flash. Some are locked at a $1/60^{th}$ or $1/90^{th}$ of a second. Check your manual.

Practice with Full Flash Principles

1. In full daylight, pop up your flash and set it at "1/1" which is full flash, or manually match it to your lens opening. Choose $1/30^{th}$ shutter speed. Unless you have a steady hand, use a **tripod** or non-movable object for support. Make an exposure of a subject within ten feet and

record the frame number and your settings.

2. Don't move the camera an inch. Keep the flash setting on "1/1." Set the shutter at $1/125^{th}$ of a second or the fastest the camera will allow. Make an exposure and record it. You will see little or no background light in your image.

Fill Flash

With fill flash, though, the ambient light is the main light. At any setting

setting for each scene. If the subject is in lighter shadow (side lit, for example), set the flash to -1.5 to -2.5, which corresponds to 1.5 to 2.5 stops less flash than full. This will allow you to pop a little light into the subject to give shadow detail without flattening the natural light altogether.

With an auto flash, do nothing except pop the flash up, point and shoot. You'll be amazed at the results.

Practice with the Fill Flash Principles
1. Set a subject with the sun behind it. If you put your subject facing the sun and the subject has eyes, it has to squint painfully. With the sun behind the subject, it is shaded, backlit. Use no flash and make a picture with the object filling half the frame. Expose using automatic metering. Show some background. You'll probably find the subject is underexposed.

2. Leave the camera position and settings the same as in image #1. Now, pop up the flash, and set it to "auto" or "-1." Record the setting and frame number. The subject will be well lit, almost as bright as the background.

3. Keep the shutter and lens set for the daylight as before. Now set the flash to -2, a difference of two stops between the aperture and the flash, such as aperture of f/11, flash at f/5.6. The flash will be almost undetectable, but shadows will not be harsh.

4. Experiment with side and front lighting. Even when the sun is directly on your subject, deep-set eyes, facial lines, and crevices in the scene may prevent adequate attractive light from reaching the nooks and crannies of your subject. Use a small amount of fill flash ($-1^1/_2$ to $-2^1/_2$ stop) and you will soften the look.

We sometimes say dark subjects devour light; it's hard to correctly expose deep-set eyes of bears, bison, and some people. Flash helps every time.

When flash would be too harsh or unreliable (you don't know its success until the film is processed), try a **photo disc** in a wide variety of sizes and colors. See the composition section "Improve the Light for a Better Composition" for examples.

◁ When flash would be too harsh or unreliable, try a photo disc in a wide variety of sizes and colors.

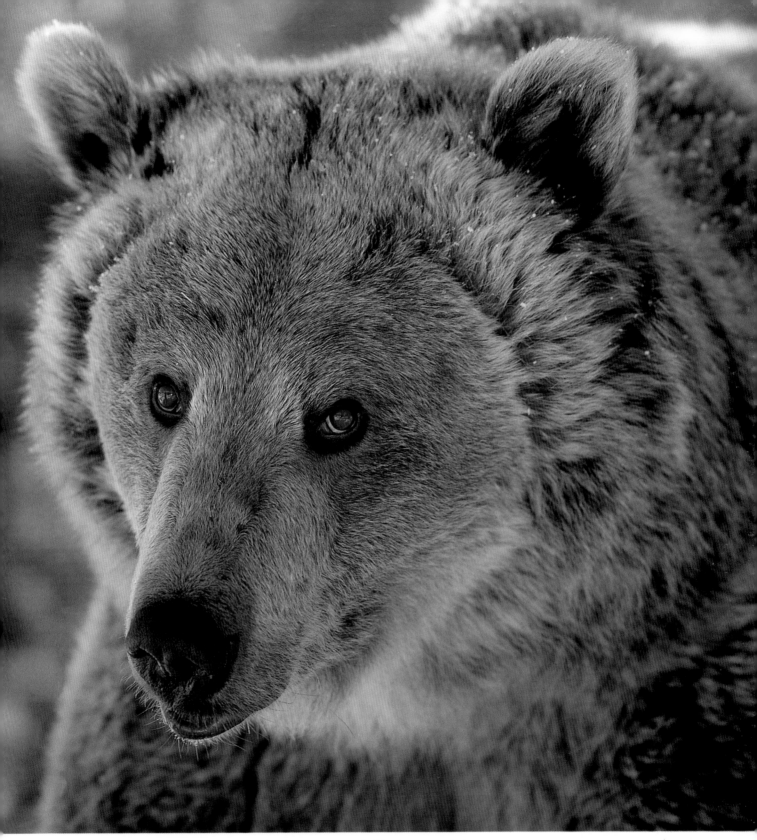

△ Fill flash helped correctly expose the dark, deep set eyes of this Montana grizzly bear, a wildlife model. The Metz flash was set to -1/2. The image was photographed with a Hasselblad 503CW (on a Gitzo tripod) using a 350mm lens with a 1.4x teleconverter.

MANIPULATING LIGHT FOR EFFECT: DELIBERATE UNDER- AND OVER-EXPOSURE

A question I ask myself every time I prepare to expose a frame of film is, "What tone of these colors am I trying to capture?" When I can determine the shade of light and how far it is from 18% **reflectance** or what nuance in the shadows I'm trying to achieve, or what I'm willing to give up in one part of the frame to emphasize another aspect, I'm ready to use my **exposure** knowledge to record the effect I want.

The first image (frame 1) is the "correct" exposure for a sunny day, metering off a **gray card** and double checked with an incident meter.

The second image (frame 2) I saw in my mind, then **underexposed** to achieve it. The scene seemed black and white, extremely contrasty. I wanted to record that on film. So I pointed my in-camera meter at the brightest glare to give me a very fast (short) exposure. It is more than a full stop underexposed from frame 1.

I also chose underexposure in varying degrees for this sunrise series (frames 3 and 4). I arrived a little late and the sun was losing its golden glow (frame 3). I took a **meter** reading off the brightest part of the scene for an exposure too brief to give detail in the darker areas (frame 4). Yet the overall impression is of an earlier time of day with richer color saturation.

I choose **overexposure** sometimes on light subjects, such as this winter scene in Yellowstone, when I want almost no detail in a "high key" scene. It gives an ethereal, almost Oriental look to the image (frame 5).

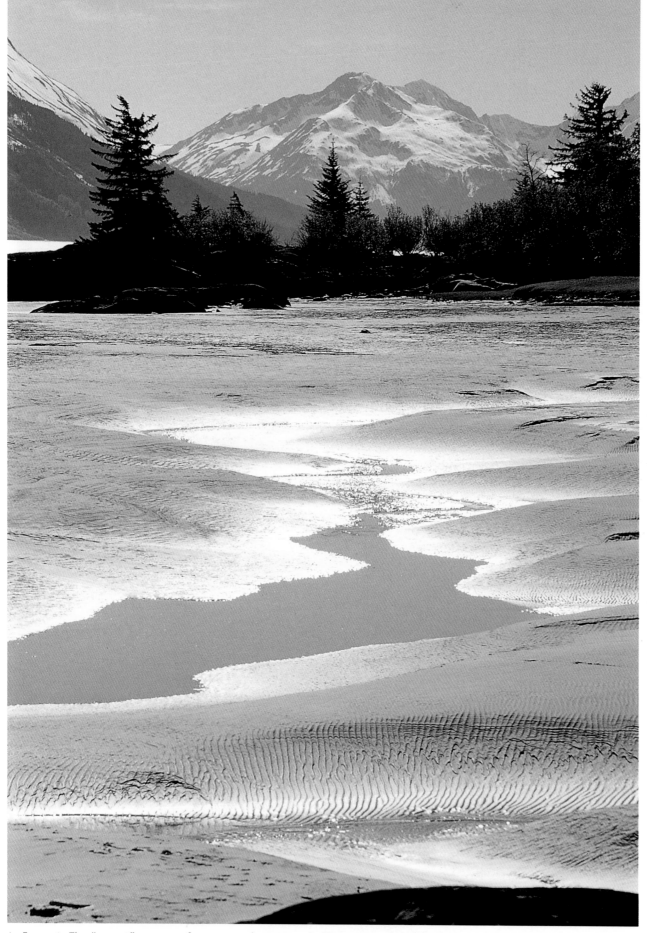

⅄ Frame 1. The "correct" exposure for a sunny day, metered off the sky and double checked with an incident meter. This image was made with a Canon EOS Elan camera and a Canon 100-400mm lens on Kodak E100S film. Location: Turnagain Arm, south of Anchorage.

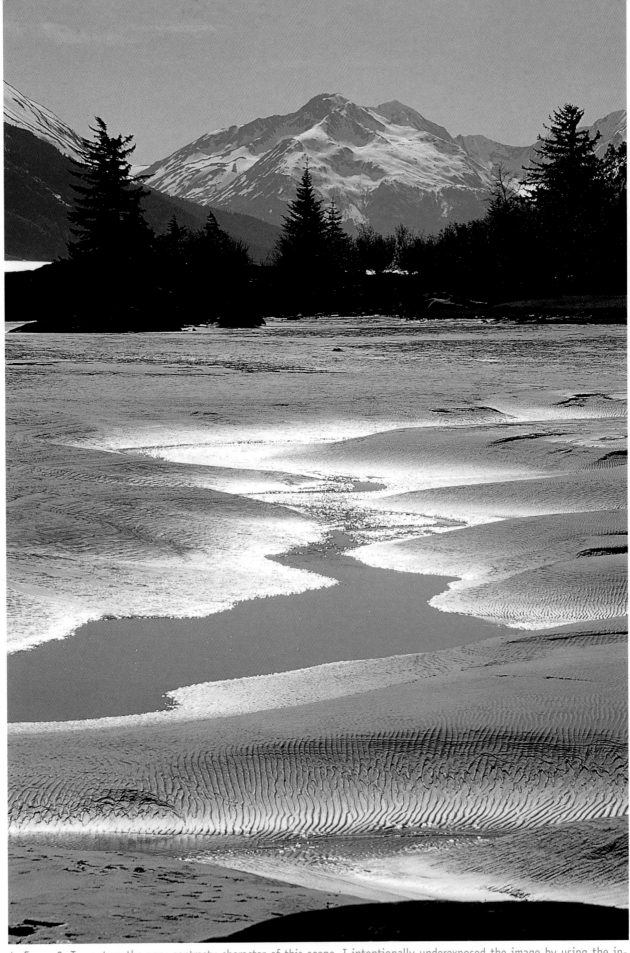

▲ Frame 2. To capture the very contrasty character of this scene, I intentionally underexposed the image by using the in-camera meter to read off the brightest area of the scene. This gave me a very fast (short) exposure.

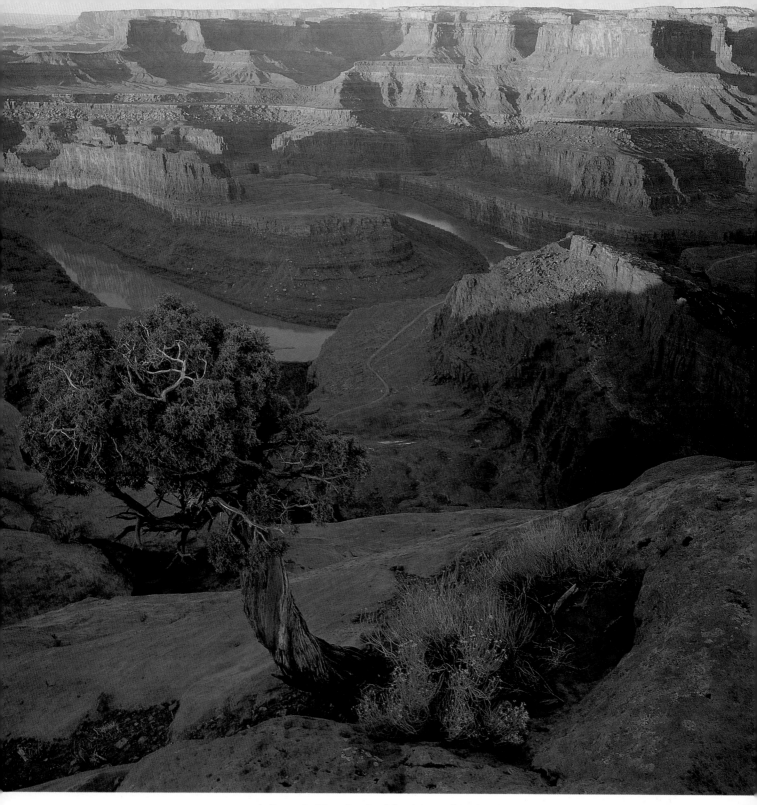

A Frame 3. When I arrived for this sunrise, the sun was starting to lose its golden glow. Location: Dead Horse Point State Park, Utah.

⋀ Frame 4. I took a meter reading off the brightest part of the scene for an exposure too brief to give detail in the darker areas. Yet the overall impression is of an earlier time of day with richer color saturation. Location: Dead Horse Point State Park, Utah.

Δ Frame 5. Sometimes I choose overexposure for light subjects, such as this winter scene in Yellowstone, when I want a gauzy, soft look with less detail. I took an incident light meter reading in the same light as the subjects, then added a half stop more exposure (for example, 1/60th at f/8 would become 1/45th at f/8).

Changing Shutter Speeds for Effect

Waterfalls

Photographs of waterfalls easily show the differences between fast and slow shutter speeds. Experimenting will guide you to your preferences. Try $1/30^{th}$ of a second, $1/4^{th}$ of a second, and a full second to see what effects you like. (In bright light, you may need to use a **neutral density filter** or very slow film to use a one second exposure.)

Your camera's "shutter priority" function helps here. With this function, you choose the **shutter speed** and the camera decides on the "correct" **aperture**. Remember, the meter will base its choice on attaining average **reflectance** (see pages 8-20 to review this concept).

Snow

To shoot falling snow, a $1/30^{th}$ of a second **exposure** produces results that look close to the way our eyes see the snow fall. Very slow shutter speeds, such as one half to two seconds, give a streaking effect almost like rain. Shoot much faster than $1/60^{th}$ and the snow will look more

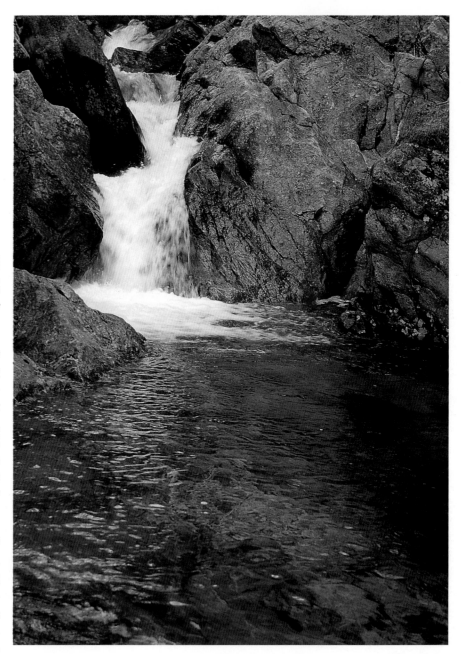

A 1/125th second shutter speed. This image was taken with a Canon EOS Elan camera with a Canon 28-135mm Image Stabilizer lens. Location: Pinkham Notch, New Hampshire.

like snowballs stuck throughout the frame.

Blowing Leaves

Blowing leaves on trees, flowers in a field – to show motion for these subjects, use exposures of one second and slower.

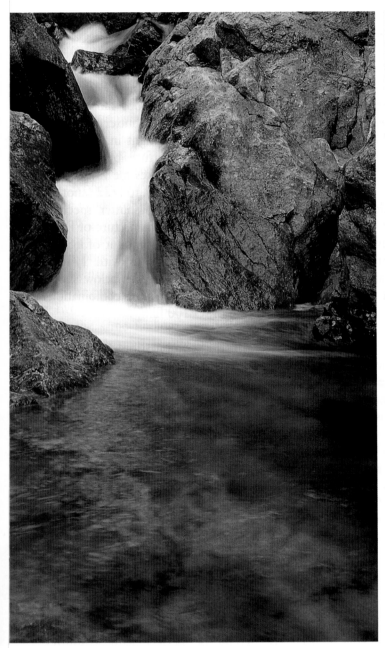

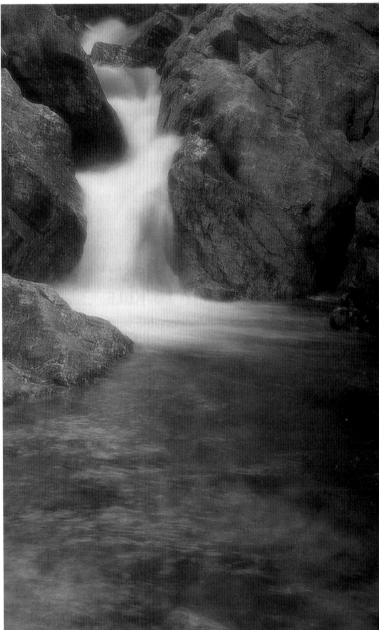

⋀ One second shutter speed.

⋀ One second shutter speed with a soft focus filter.

TEST YOUR EYE:
EXPOSURE

In the following series of four images, evaluate the **exposure** of each image. Decide if each one is over- or underexposed for your tastes. Try to determine how the **meter** did it, and what you would do differently. My comments follow the series of images.

Frame 1. Y

Frame 2. ➢

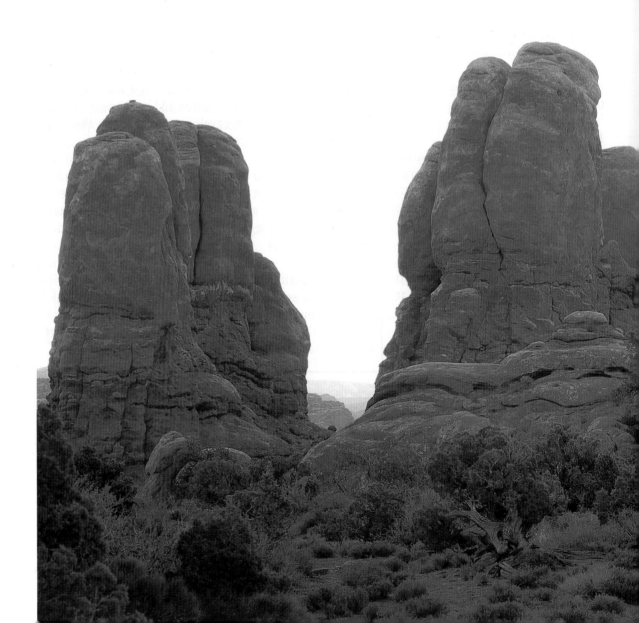

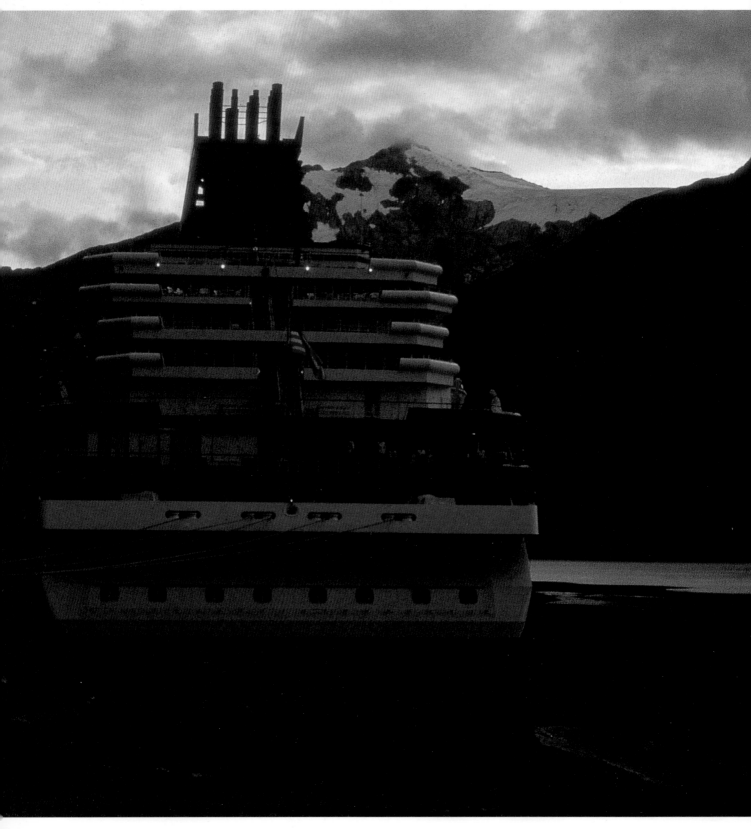

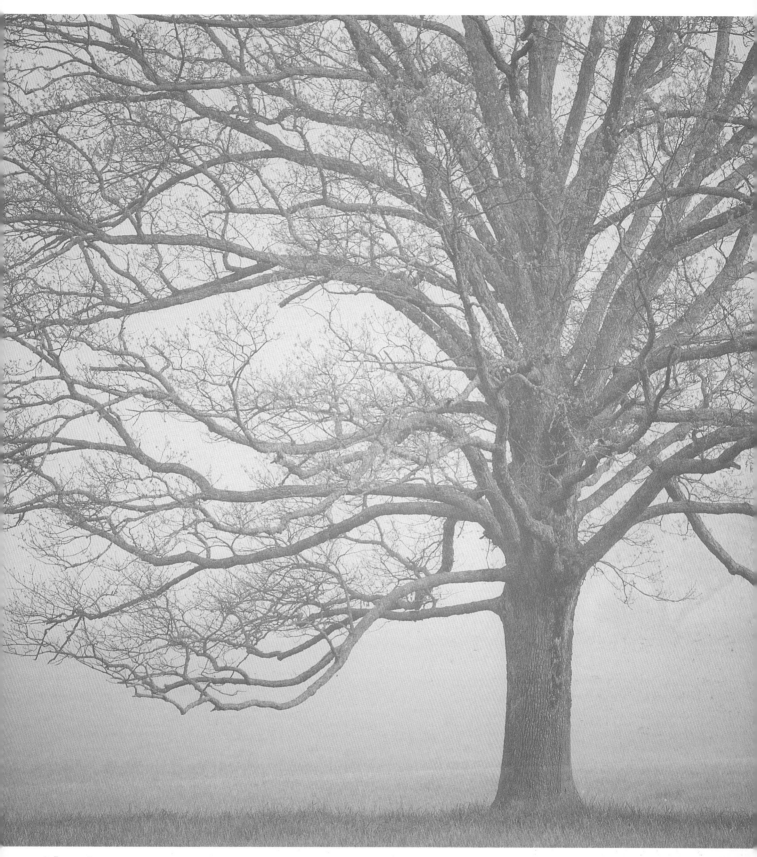

△ Frame 4.

My Comments

Frame 1

What is the photographer trying to say? If it's to show detail in the spires (from Arches National Park in Utah), the exposure is right on. But in this case I was photographing a sunset, and the detail in the rock formations detracted from my message rather than adding to it. I had pointed the **meter** to the lower third of the frame, which gave an overall "too dark out here – open up" message. That's why there's no rich tone in the sky. In frame 5 (page 39), however, I aimed the meter at the brightest part of the sunset and "**underexposed**" the scene for a silhouette effect.

Frame 2

The subject is clearly underexposed, caused by the camera reading a lot of **reflectance** off the background. In frame 6 (page 40), I popped up the flash, set it to "fill" (or –2), and made another exposure.

Frame 3

As with frame 1, first we need to determine what response the photographer wanted from the viewer. The image you evaluated gave the impression of a ship docked at sunset or sunrise, not much more detail than that. I took a reading from the brightest part of the sky to underexpose the ship. The image in frame 7 (page 41), though, tells the viewer the ship is the subject, not the light in the sky, so I metered on the ship and allowed a longer exposure to give more information.

Frame 4

A little light for your tastes? The exposure of this image, made in Cades Cove at the Great Smoky Mountains National Park in Tennessee, is two-thirds of a stop over what the incident meter reading gave me in the same light. I couldn't find enough of a patch of medium toned area in the scene for the in-camera reflected meter, so I put myself in the same light as the tree and took a hand-held incident meter reading. I made one exposure at that reading, and then tried one more exposure, opening up two-thirds of a stop. In this case, I opted for a slower **shutter speed** and left the **aperture** the same. I like the "feel" of this lighter exposure best.

≺ We need to determine what response the photographer wanted from the viewer.

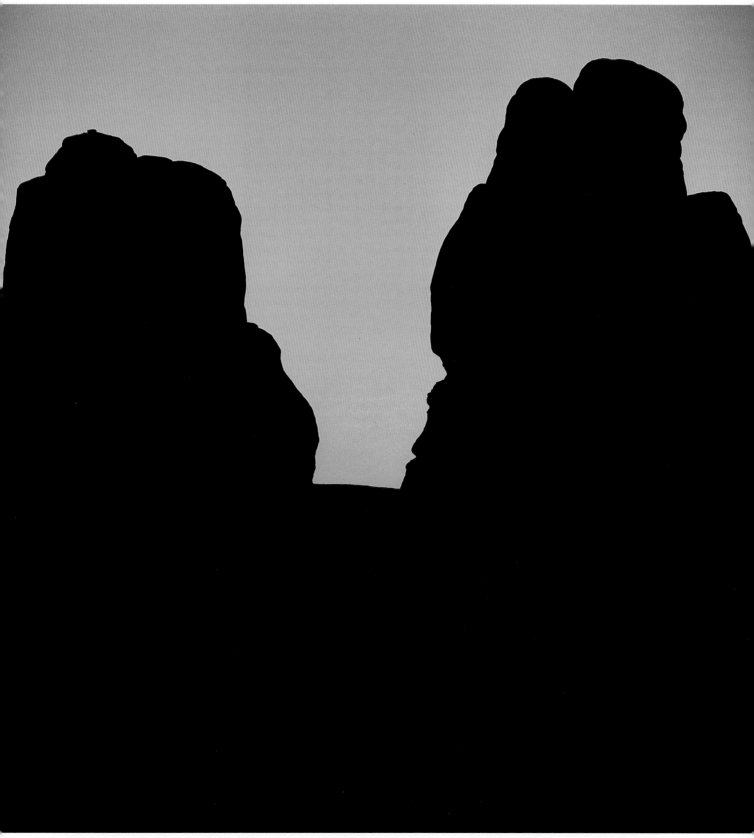

Frame 5.

▲ Frame 6.

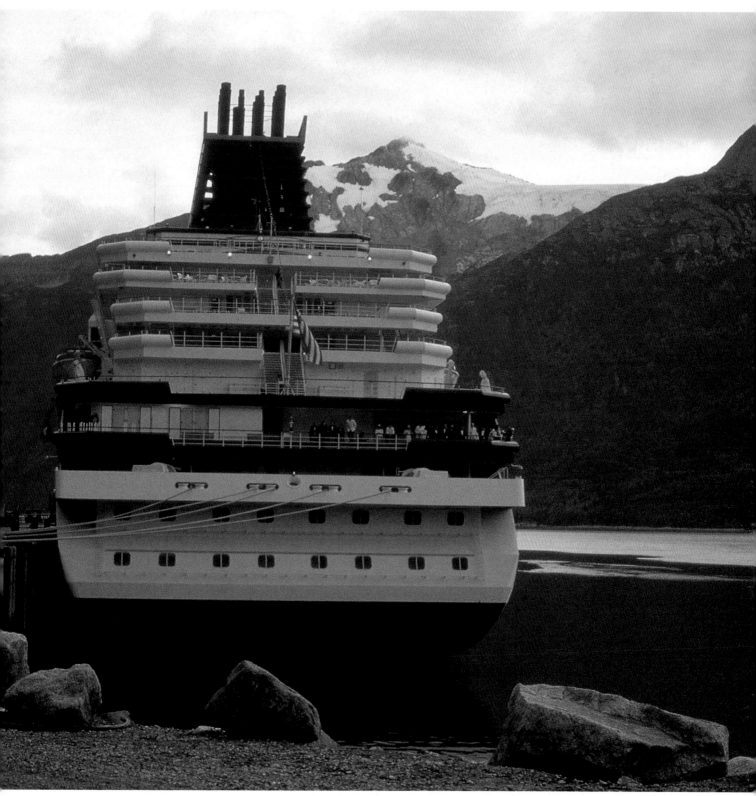

A Frame 7.

"ON THE SCENE" WITH EXPOSURE CHALLENGES

Windy, Wet Conditions

Photographing in misty, foggy conditions is one of my favorites because there are not many people to work around and Mother Nature puts on a great show. On this morning in the Great Smoky Mountains National Park (opposite), the mist turned to a downpour and the breeze became a gale.

Your first reaction might be to use as high a **shutter speed** as possible to stop the motion of the leaves. Instead, I find working with the conditions and even accentuating them can create an expressive image. When the weather turned wet and windy, I thought about how best to show it on film.

I chose a moderately long lens and a one second **exposure** – the slowest shutter speed that my film speed, the **ambient light**, and the lens's smallest **aperture** would permit.

Then I determined the aperture after taking a **meter** reading on the leaves. At one second for the shutter speed, the meter suggested f/32 for the aperture. Did this make sense? A sunny day exposure would be 1/125th of a second at f/16 using ISO 100 film. One second at f/32 is

how many stops more open than that? Let's compute. 1/125th down to one second is seven stops more open; f/32 is two stops more closed – a net difference of five stops from the sunny day exposure. Was the day five stops "darker" than a sunny day? I usually figure that five stops compensation will work for photographing on a dark overcast sky, often with rain, early in the morning – exactly the conditions I was working in.

In summary, first decide on the effect you want for a day like this and choose your aperture or shutter speed. Set that. Then take a meter reading or **gray card** reading to determine the other setting. Finally, think it through to evaluate whether the combination makes exposure sense for the light conditions. The meter is the guide, but *you* have the brain.

< Determine whether it's the shutter speed or the aperture which will best express your vision, then set that control first.

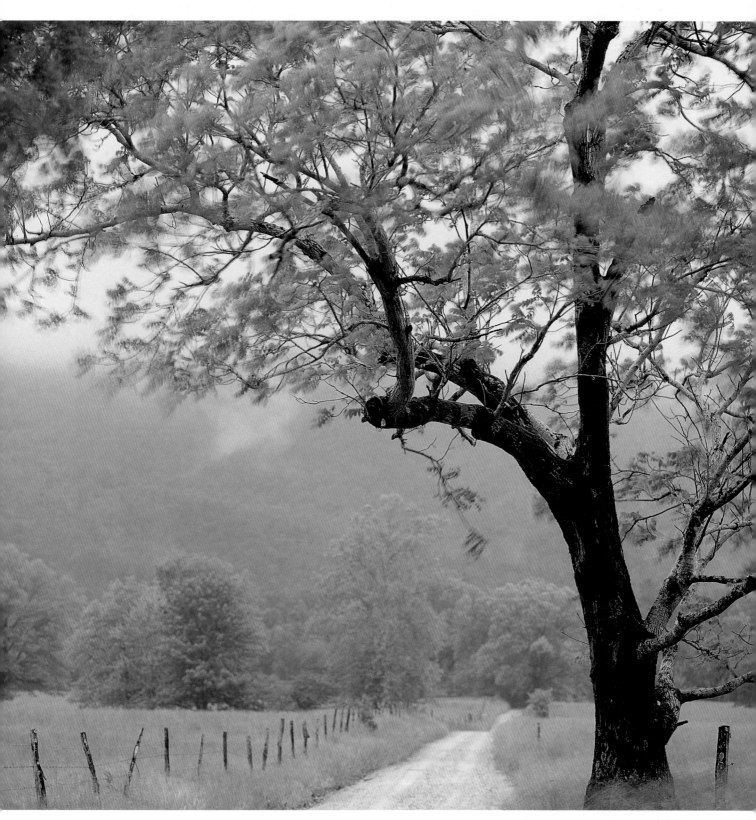

A On this rainy, windy morning on Sparks Lane in the Great Smoky Mountains National Park, I thought about how best to show the weather on film. I chose a moderately long lens and the slowest shutter speed that my film speed, the ambient light, and the aperture would permit. Location: Cades Cove, Great Smoky Mountains National Park.

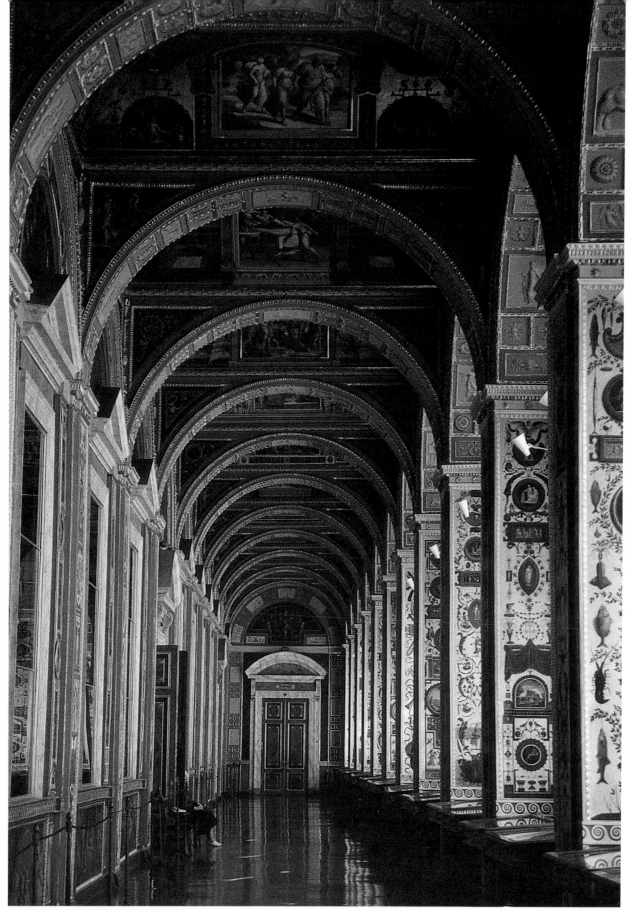

⋀ I use fast print film (or push slow slide films) in many museums, where flash is often not permitted. Print films in the ISO 800 to 1000 range make sharp exposures without a tripod. I used Fuji's RMS 100-1000 ISO slide film pushed to 1000 for this hand-held image in St. Petersburg's Hermitage museum, made with a Canon EOS Elan camera with a Canon 28-135mm Image Stabilizer lens.

Indoors Without Flash

I use fast film in many museums, where flash is not permitted. Films in the **ISO** 800 to 1000 range make a sharp exposure without a **tripod**. I can also **push** ISO 100 film two stops to ISO 400 for slides, or Fuji's specialty RMS film to ISO 1000. If you choose to push your film in low-light situations, make sure to inform the lab that the film has been pushed and by how many stops. Development time must be increased for pushed films. A side effect of pushing film is increased **graininess** in the final image – but this is generally a secondary concern to a sharp picture.

Inside this museum in Russia, depth of field was unimportant compared to being able to handhold the camera at the fastest speed I could. In my mind I was thinking "maximize speed" in this situation. With an ISO 100 film, my **meter** probably suggested an **exposure** combination in the range of eight stops darker than a **"Sunny 16"** kind of day, something like 1/8th of a second at f/4.5. I know I can't hand hold anything less than my lens length reliably without camera shake. For example, with a 70mm lens I try to hand hold only for exposures of 1/60th of a second or faster.

I had two options inside the museum. ISO 800 film would allow an increased shutter speed of 1/60th at f/4.5. This means that I had at least a fighting chance for making a sharp image. My second option was to push ISO 100 film three stops to ISO 800 and achieve the same results. If you haven't used the faster films lately (or pushed your ISO 100 slide film to at least 400), you'll be amazed at how sharp your images can be.

< If you haven't used the faster films lately (or pushed your ISO 100 slide film to at least 400), you'll be amazed how sharp your images can be.

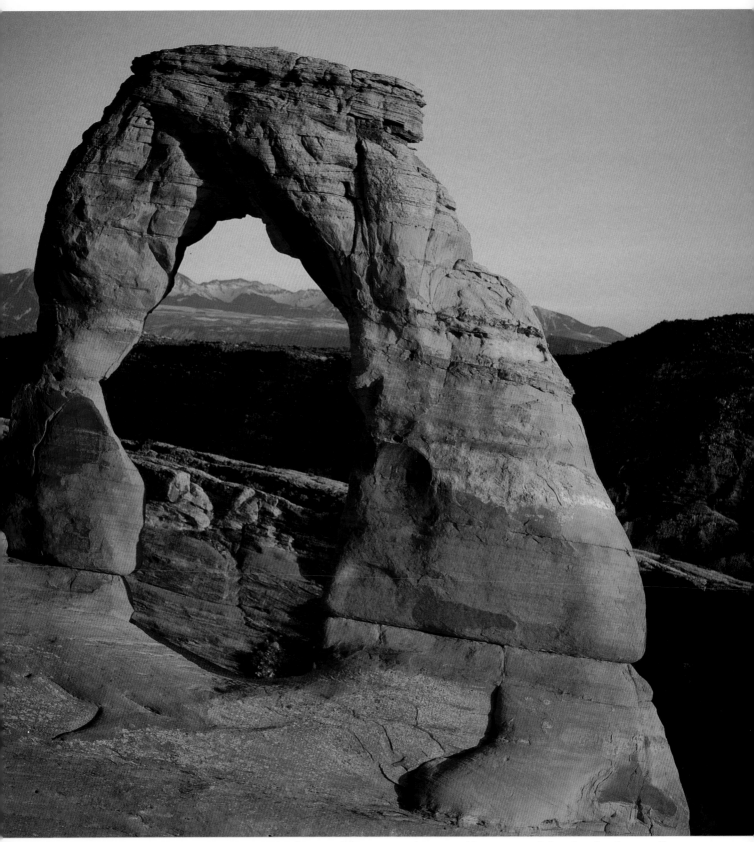

▲ When the scenery and light come together for a special moment and you are able to capture it in a few fast frames, all your exposure and composition practice pays off. Location: Delicate Arch at sunset, Arches National Park, Utah.

COMPOSITION

When you are comfortable making **exposure** decisions to yield the desired effect, the **composition** elements making for a dynamic, unforgettable image take center stage.

What two or three pictures do you consider all time favorites? Are they simple, uncluttered, strong in their own right? Mine are. We are bombarded with so many pictures every day that only the ones making the strongest statements stand out. I compare powerful photos to robust writing or well-designed cars. Materials such as words, film, or metal are used sparingly, beautifully, thoughtfully.

The following section is designed to teach you how the professional nature photographers compose their images.

◄ We are bombarded with so many pictures every day that only the ones making the strongest statements stand out.

DETERMINE THE SUBJECT

You've heard the saying, "If you don't know where you're going, it doesn't matter how you get there." It couldn't be truer for composing a picture. If you can't decide what one or two elements caused you to stop and want to make an image in the first place, it's difficult to **compose** well. My thought process goes something like this: "What a scene! Is it the colors I'm drawn to, the quality of the light, a subject in particular? The texture of the subjects? The forms? What makes this scene special? Will it work on film?"

Most people include too much in the scene. They love everything in front of them, but don't stop to think that the camera will have to compress it all into one dimension and not be able to record any of the aromas, the warmth of the sun, or the sounds of the birds and waterfalls.

In this first example (opposite page), excitement over the waterfall initially limited my ability to organize the frame well. I included so much rock in the foreground that the waterfall was somewhat obscured. The second image was made after I slowed down and thought about my main subject and how best to isolate it.

You may find the next image of melt water (page 50) somewhat "unfinished." I haven't completed the scene, but only shown what is important to me – the glacial melt water and the spring flowers. I **cropped** everything except a few flowers and a slice of the water to sharpen the contrast between the delicate blooms and powerful river. By limiting your view, I'm trying to push you beyond the borders of the frame, adding some tension and drama to an otherwise pretty ordinary scene.

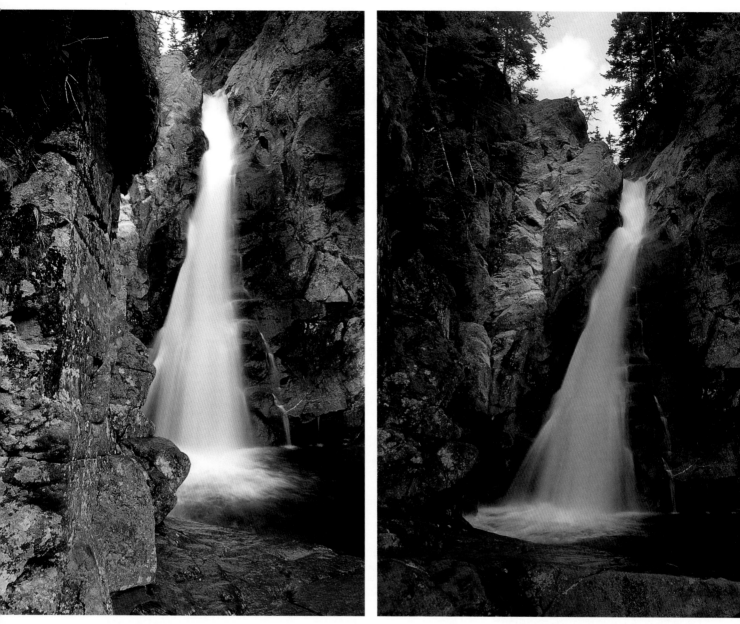

⋏ (Left) In the first example, the frame is not organized well. There is too much rock in the foreground and the waterfall is somewhat obscured. (Right) In the second frame, the main subject is more carefully isolated. Location: Glen Ellis Falls, New Hampshire.

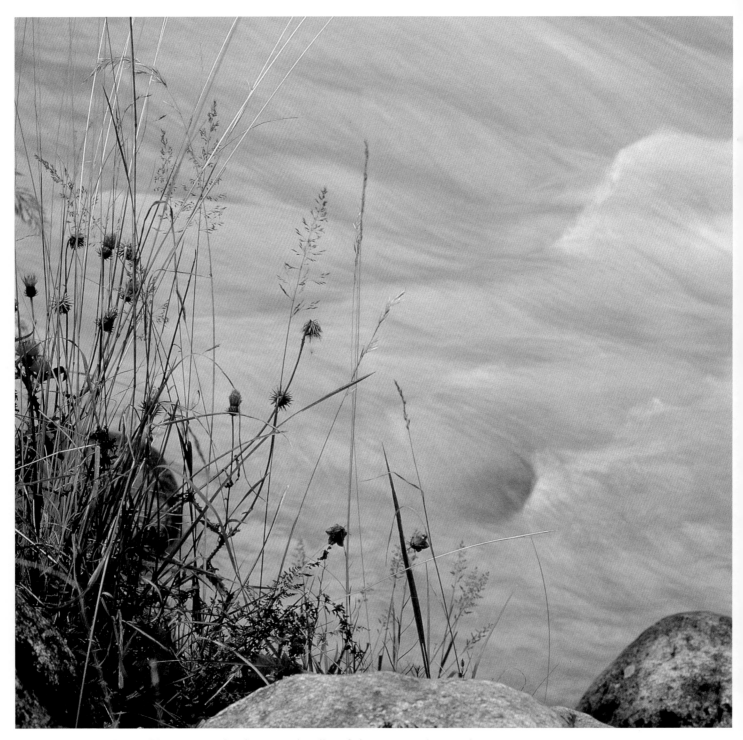

A I cropped everything except a few flowers and a slice of the water to sharpen the contrast between the delicate blooms and powerful river. Location: Lauterbrunnen Valley, Switzerland.

CLEAN UP THE IN-CAMERA "CANVAS"

To create well-composed images, the first step is to clean up the in-camera "canvas." This means ridding the frame of distractions – or finding a creative way to use them productively.

It's almost unavoidable when we're in a place with great light, great subjects, and solitude – where all the elements come together – that we have lapses in tidiness and concentration within the frame.

Frame 1 (on the next page) shows my enthusiasm overtaking my discipline to examine all four corners of the frame. The branch in the upper right adds nothing and distracts from the sunrise and the ship. Frame 2 is cleaned up, allowing the ship and dock to be the center of attention. Frame 3, though, is using the distraction to advantage – it fills in an area somewhat lacking in the second image.

Sometimes the clutter is the subject, forming an interesting pattern, as in the images on pages 54 and 55. In frame 4, washed-up coral, taken as a grouping and photographed about a foot above it, tells a story of the sea's power, of rounded shapes, of a pleasing pattern. I used a **soft focus filter** to heighten the effect. In frame 5, the dew on the leaves, nothing more, organizes a very busy scene into just two elements.

When you think you're finished with the subjects in the viewfinder, look around for yet another composition. I bet it's there.

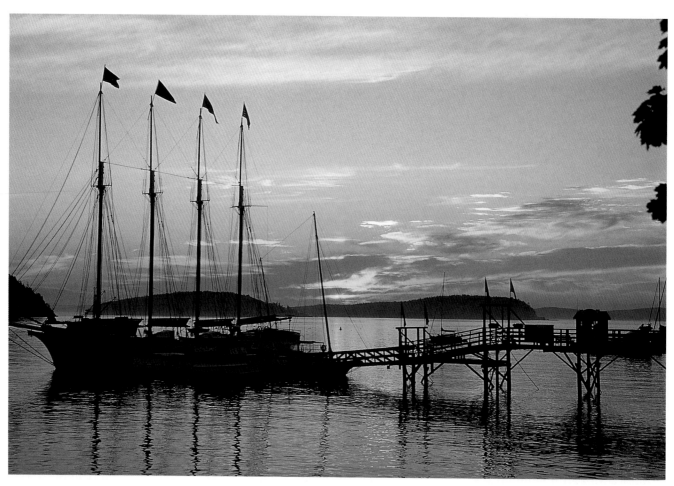

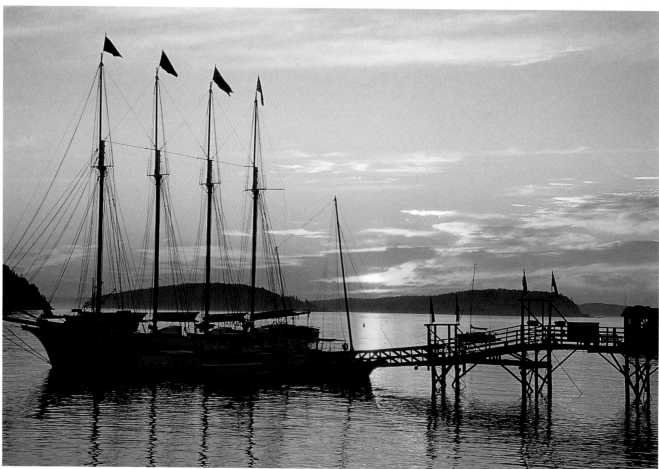

≺ Frame 1 (top, opposite). The branch in the upper right adds nothing and distracts from the sunrise and the ship. Location: Walking path on Frenchmen's Bay, Bar Harbor, Maine.

≺ Frame 2 (bottom, opposite) is cleaned up, allowing the ship and dock to assume center stage. Location: Bar Harbor, Maine.

ʌ Frame 3 (above). The leaves which were a distraction in frame 1 are used to an advantage – they fill in an area somewhat lacking in frame 2.

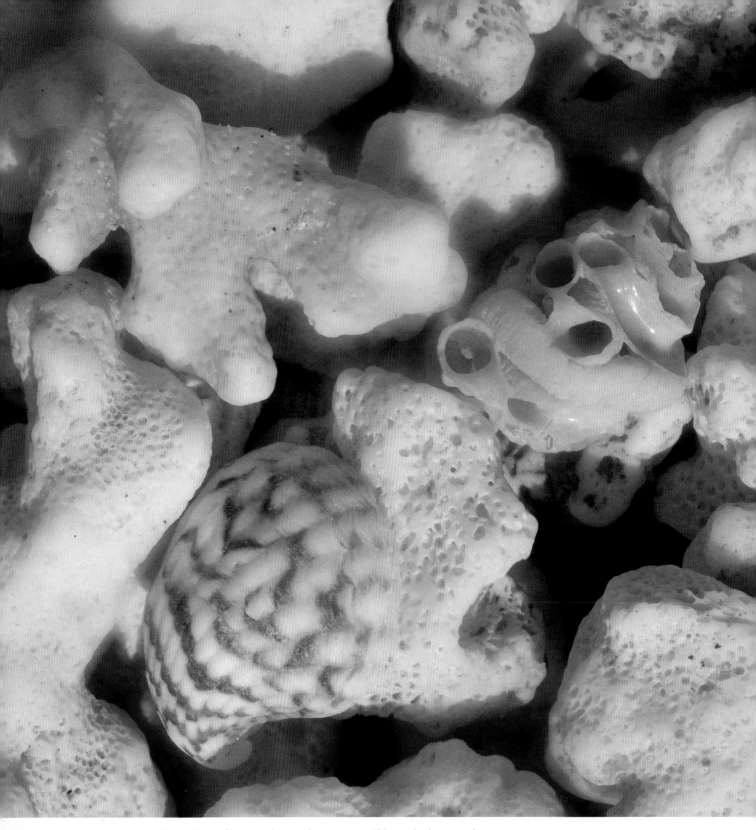

▲ Frame 4. Sometimes clutter forms an interesting pattern. This washed-up coral was photographed about a foot above it with a soft focus filter. Location: Galapagos Islands.

▽ Frame 5. The dew on the leaves organizes a very busy scene into just two elements. Location: St. Louis Botanical Gardens, Missouri.

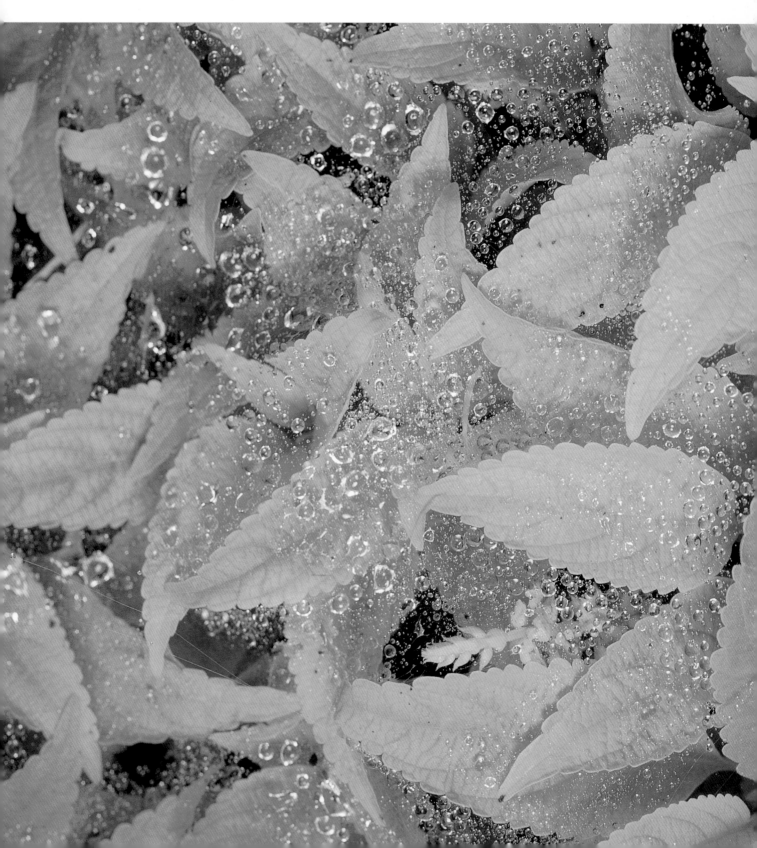

MASTER DEPTH OF FIELD

Master **depth of field** – and use it as your secret weapon.

When you're stuck with background objects competing with your primary subject, the camera's ability to limit depth of field through smart aperture choice is a huge asset.

For example, if my subject is only the fence post with a hint of mountains in the background, as in frame 1, I open the **aperture** as wide as possible (f/4 in this case) and blur the background. Of course, it also helped that I moved in as close as I could to limit the depth of field at the chosen aperture.

In the second example (frame 2), I've used an aperture of f/32 to maximize the depth of field, still anchoring the fence as my primary subject in the foreground, but opening the scene up to much more detail. Both images were made off the Jackson Hole Highway in Grand Teton National Park, Wyoming.

For more examples of shallow depth of field, see pages 59, 65, 68 and 72. Some examples of great depth of field are on pages 9, 25, 60 and 78.

≺ Master depth of field – and use it as your secret weapon.

Frame 1.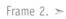

Frame 2.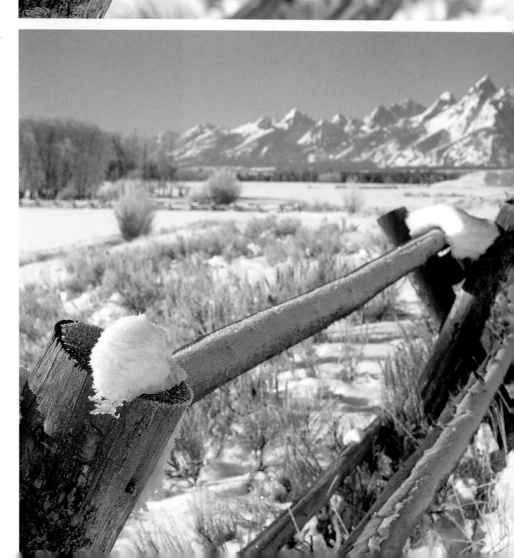

Move the Subject Off Center

To improve your compositions, move the subject off center – the frame is not a dartboard.

Did you notice in the previous examples the subjects were not tiny points dead center with a lot of empty sky or bland foreground? Most autofocus cameras have their focusing spot in the center, and the tendency is to leave the subject there.

Many of you are saying this is an amateurish problem, but nearly half the portfolios I review still show images with a small subject, static and lifeless in the center.

On most **SLR**s and point and shoots, by pushing halfway down on the shutter button to lock in the focus and metering, the camera can then be moved to a better composition. These examples, made on Rt. 16 north of Berlin, New Hampshire, show, first, the effect of a dead center subject (frame 1); then using the center as a backdrop to a subject dominating the center (frame 2), and finally eliminating the center altogether (frame 3). In the third image, the sun is just a prop to emphasize the subject.

Δ Frame 1.

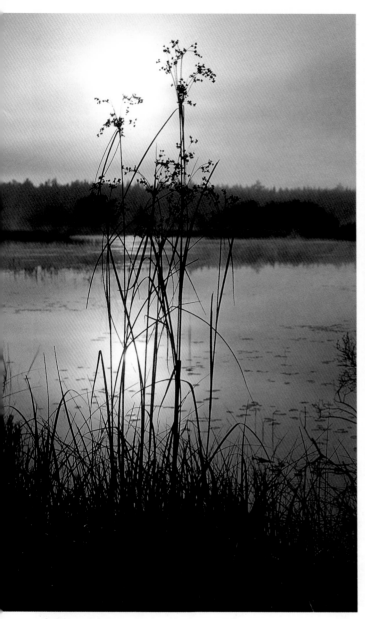

Frame 2.

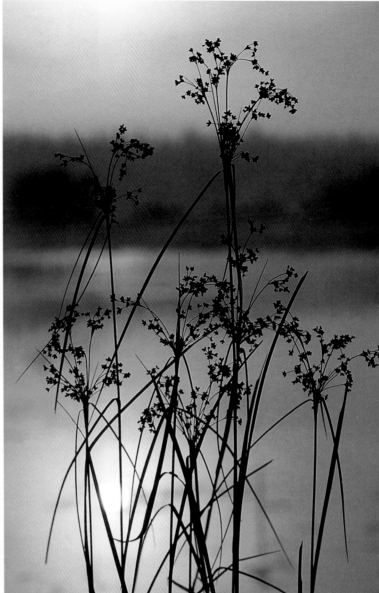

Frame 3.

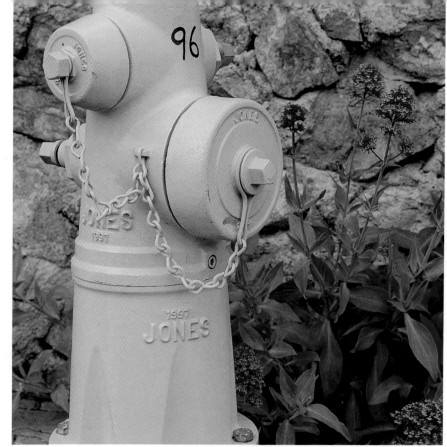

ANCHOR THE FOREGROUND

One of the cleanest and simplest ways to move the subject from the center is to "anchor" it in the lower third of the frame.

The colorful hydrant in frame 1 would sit as a static symbol in the middle of the frame, but positioned off center, it draws the eye in.

The barnacled wheel in frame 2 nearly fills the lower foreground, providing a magnet for the eye.

⋀ Frame 1. Location: Catalina Island, California. Made with a 120mm Hasselblad lens.

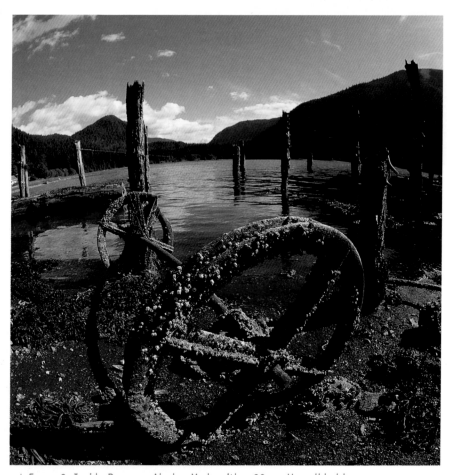

⋀ Frame 2. Inside Passage, Alaska. Made with a 30mm Hasselblad lens.

LEAD THE EYE INTO THE FRAME

When the subject calls for a dramatic way to lead the viewer's eye into the frame, dominate the foreground with it. The eye leads from large to small subject and therefore grabs the largest subject closest to it and moves back into the frame. This works well with roads and trails, buildings, fences and rivers. Here, a stone wall leads you into this image photographed in LaRochelle, France.

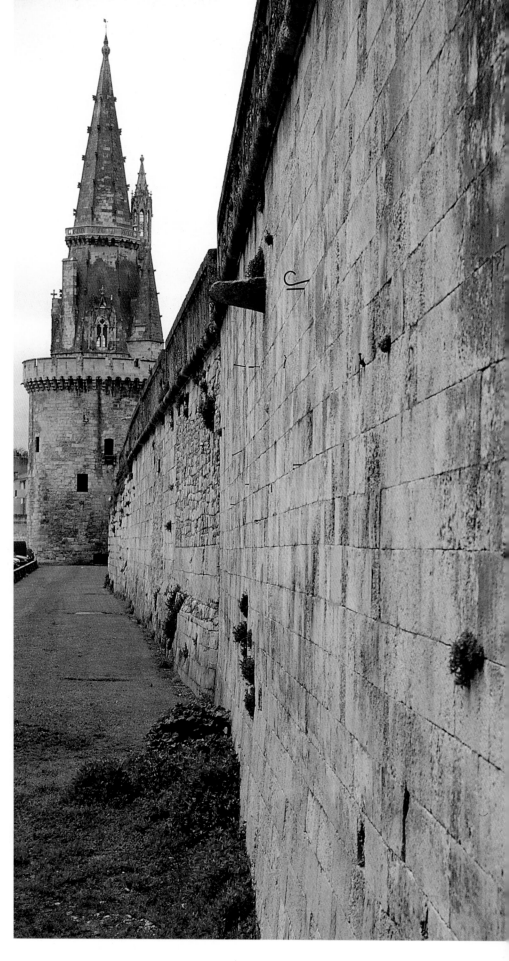

LOOK FOR LINES, DIAGONALS AND CURVES

When the eye moves at an angle into the frame, it stays interested from foreground to background. That's why some of the most compelling images use the techniques of suggesting motion through diagonals and curves. They lead the eye from the beginning of the curve through the end of it. Often there is a surprise at the end – a mountain or a bright chair or a beautiful building.

In frame 1, it's a diagonal telling the story of hiking on the Monte Rosa Hut Path in Zermatt, Switzerland. The progression is from a simple day hike where we find the hiker, to the technical mountain in the middle ground, then the ultimate Swiss climbing adventure of the Matterhorn in the background.

Frame 2 shows a foggy sunrise toward the "Three Gossips" in Arches National Park, Utah, as I lead your eye down the park road from foreground to background. Each third of the image carries its weight in telling the story.

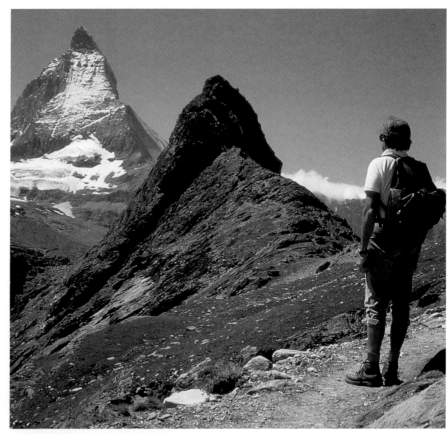

Λ Frame 1.

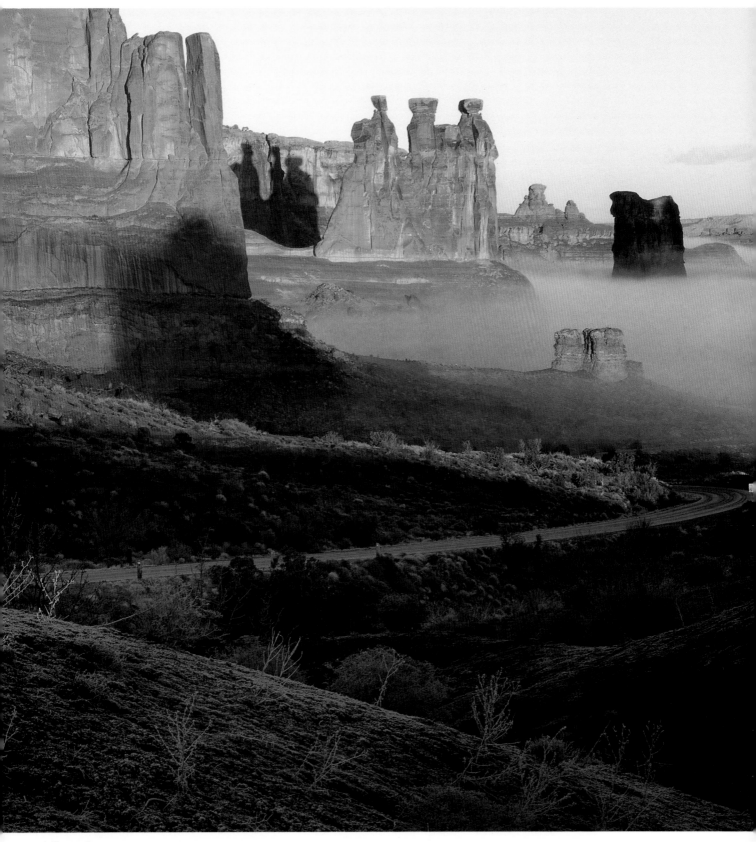

▲ Frame 2.

PROVIDE INTEREST THROUGHOUT THE SCENE

Once the eye is moving through the frame, where do you want it to go? I like to see something captivating in each half or third, or from the foreground to the background, as in this photograph from Cades Cove in the Smokies. I used extreme **depth of field** to achieve my goal – giving equal weight to each subject.

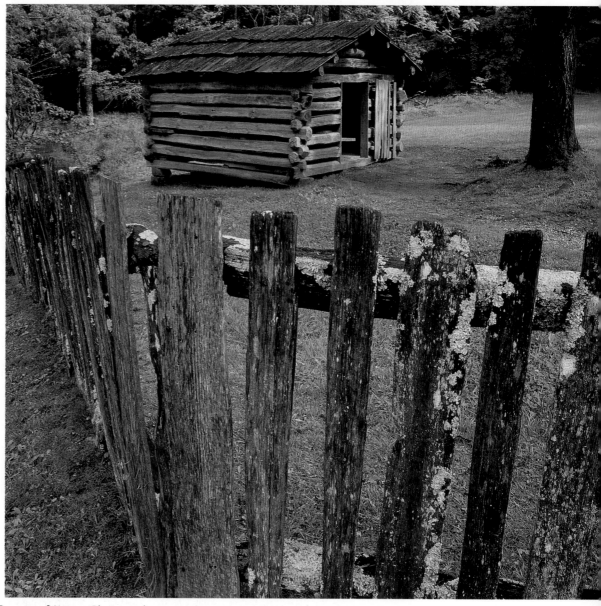

FILL THE EMPTY SPACE

As I stood upright at the water's edge in Milan, New Hampshire, my view was different from this knee-high image (top). At eye level, looking between the reeds at the reflection of the mountain, there was a lot of water with "nothing going on." Choosing a low angle allowed me to fill the empty area of water with the reeds, leading the eye up to the reflection.

It's possible, though, to cause a distraction if the foreground "breaks into" the background, as it does in the second image (bottom).

Be careful to position the foreground so that it gently leads into the background without interfering with it. Notice how in the image on the previous page, the fence does not quite "touch" the lower edge of the cabin.

Getting in the Right Light vs. Getting the Light Right

I consider **exposure** the topic if we're trying to get the *light right*, that is, record the light on film the way we like it best – such as warm tones in a sunrise. Getting in the *right light* for the scene, though, I consider a **compositional** topic. Here's what I mean.

When the light on a subject allows the elements to draw equal attention (as in frame 1 with even, shadowless light), there is no harsh contrast between sun and shade, just uniform tones. The light is well balanced. Frame 2 shows early morning light, changing the scene altogether. You may prefer one of these to the other, but I like them almost equally. I do not like frame 3, which is full of hot sun, harsh shadows, and void of mystique.

Along with finding great subjects and making superior compositions, lighting has a lot to do with whether your image becomes a "winner." When you are not in control of time of day, quality of light, or angle, try some quick fixes in the next section.

Ⱥ Frame 1. Location: Glen Ellis Falls Trail, Pinkham Notch, New Hampshire.

Ʌ Frame 2.

Ʌ Frame 3.

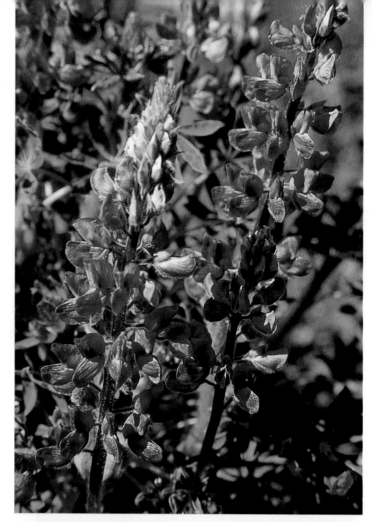

IMPROVE THE LIGHT FOR A BETTER COMPOSITION

Frame 1 shows lupine in bright midday sun. This light is not attractive for close-ups or scenics unless you are producing post cards of blue-sky days or selling to the church bulletin market, which prefers "optimistic light" for their covers.

Softening Light

I prefer to soften the light using simple accessories. A **photo disc** or your shadow will take the sun off of the subject and heighten the color saturation (figure 2). A disc will allow more of the **ambient light** to penetrate than your shadow or baseball cap will. Discs or shades come in a variety of "translucencies," so find one you like at a pro photo store and keep it in your camera bag. It turns the worst light of day into very productive close-up time.

If you carry a **mirror** or gold **reflector** with you, it's easy to add a little warmth to the shade (figure 3). If you prefer some sun in the frame, try using a **diffuser** or **soft focus filter** to simply spread the light and moderate the intensity (figure 4).

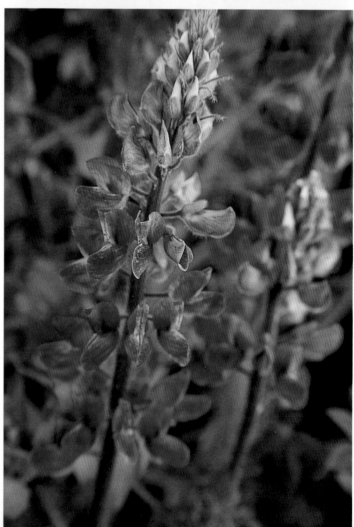

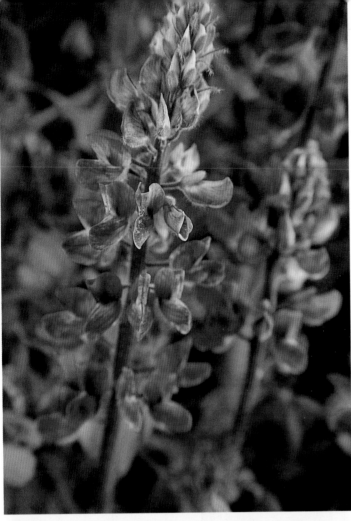

◁ Frame 1 (top, opposite). Lupine in direct sunlight. Location: On Turnagain Arm, south of Anchorage, Alaska.

◁ Frame 2 (bottom, opposite). Light modified by the addition of a photo disc.

◁ Frame 3 (top, this page). Warmth added to the light using a gold reflector.

◁ Frame 4 (bottom, this page). Soft focus (with a diffuser or soft focus lens) spreads out the light.

Enhance the Light

I found the light cold and blue this particular morning on "bowling ball beach" in Acadia National Park. By adding an inexpensive **warming filter** (frame 1), the quality of the light more closely matched the light of sunrise. I then experimented with a **sepia filter** (frame 2) and finally added a piece of black porous mesh or diffuser on top, for a foggy look (frame 3).

I used to consider the time after sunrise and before sunset a "wasteland" without productive, interesting light, but not anymore. Now I can work a landscape or a small patch of flowers, plants, or rocks, or even people candids, for hours because I can control the light on my subjects – no more long lunches, naps, and doing laundry mid-day!

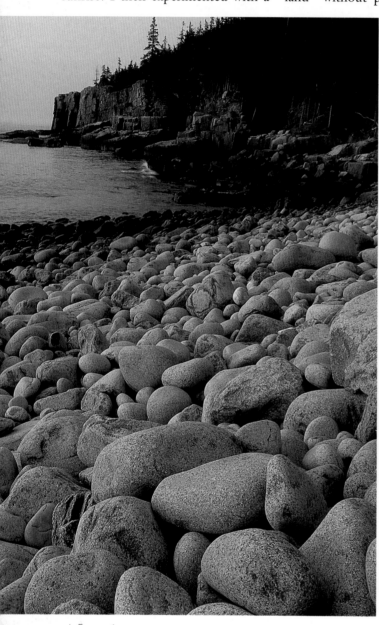

⋏ Frame 1.

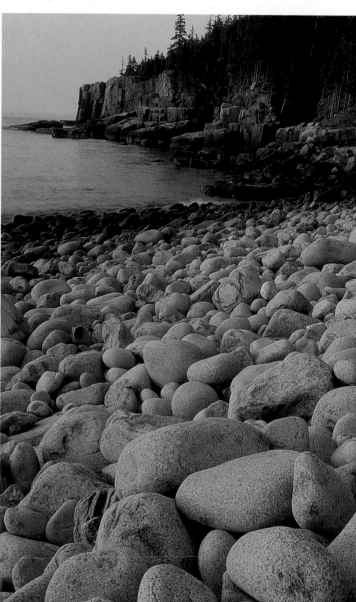

⋏ Frame 2.

Frame 3. ➤

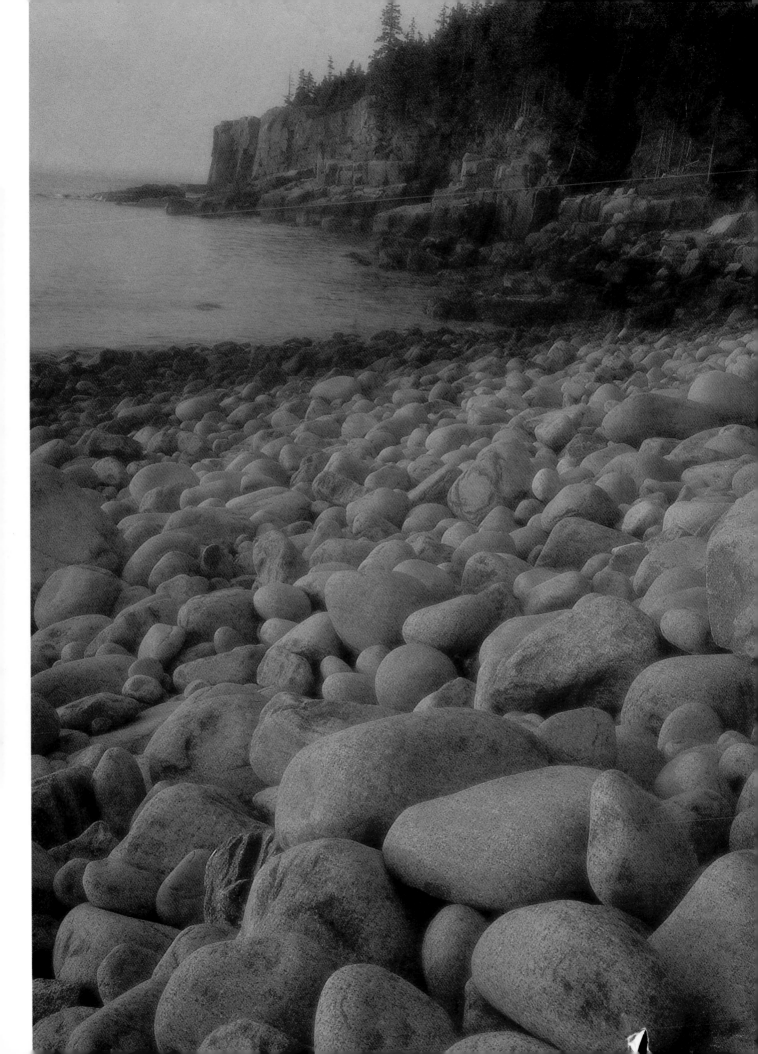

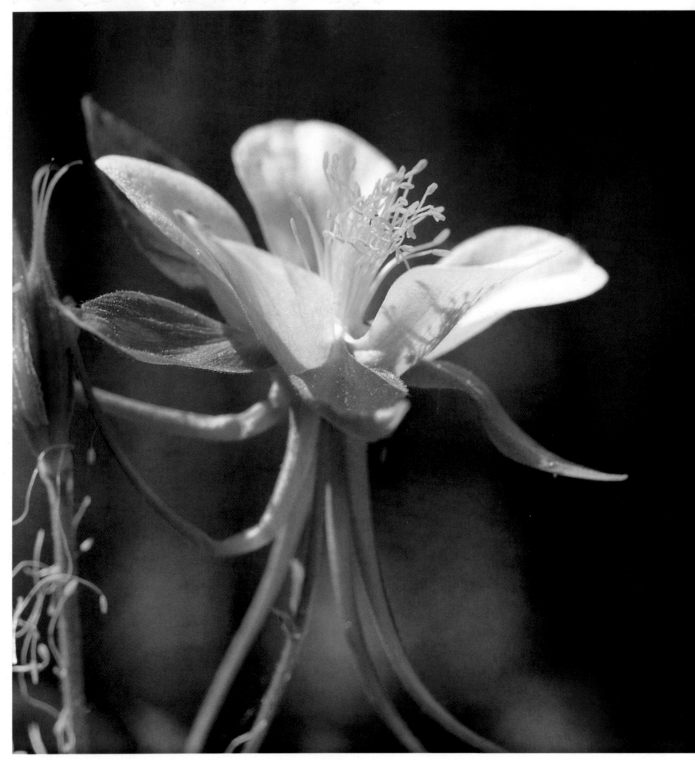

▲ Frame 1. Both frames shot with a Hasselblad 500C/M camera with a CF120mm lens and a 32mm extension tube on a Gitzo tripod with a Kirk ball head and Kaiser four-way focusing rail. Location: Horse path along Eagle Vail, Colorado.

Wait for Improved Light

Are accessories to alter the light too cumbersome to carry, or too manipulative for the purist in you? Then practice a technique all professionals use to their advantage: wait for the scene's light to improve. Sitting tight is one of your greatest "secret weapons" in bringing home superlative images.

If your mind's eye can imagine this delicate Colorado columbine (frame 1) without the bright sun detracting from its softness, wait for a wisp of a cloud to move in, or find a flower shaded by a tree or bush (frame 2).

If you saw frame 1 on its own, you might like it perfectly well. It doesn't have completely harsh light on it, the background is subdued and the colors are of a nice hue. But the longer

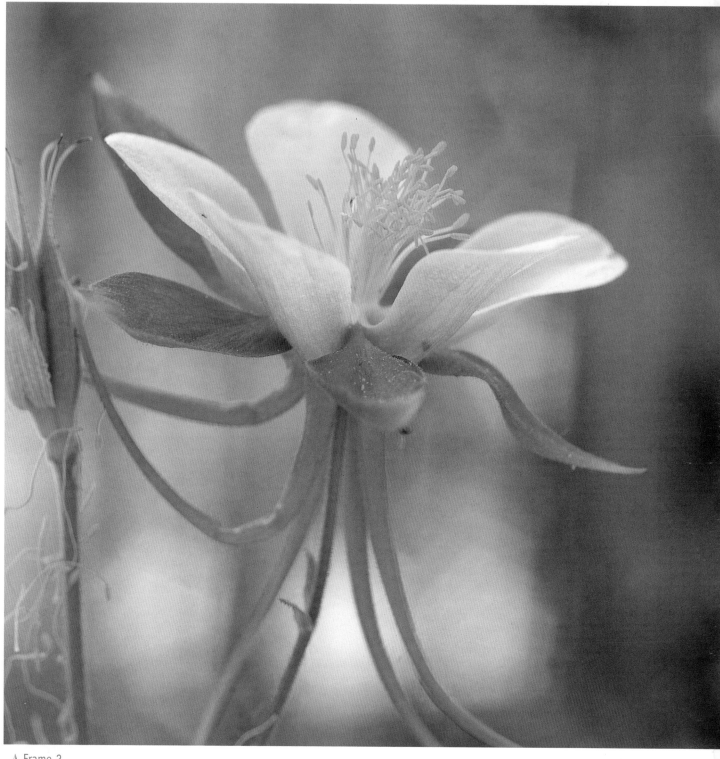

▲ Frame 2.

I looked at the flower, the more I wished for subtler light to shade the brighter areas. To capture this image, I metered off a **gray card**, which indicated a 1/180th of a second exposure at f/8 – 1.5 stops more open than a **Sunny 16** exposure of 1/125th at f/16 using ISO 100 film (see page 32 for an full explanation of the Sunny 16 rule). With an **extension tube** and muted sunlight, this made sense.

Looking at frame 2, you can see what a difference a thin cloud can make. I waited for the sun to hide behind either a jet trail or a light cirrus cloud and quickly made a couple of frames. I was all set up; I just needed to be patient. These are the saturated hues I saw in my mind before the sky cooperated. The **exposure** was half to two-thirds of a stop more open than in frame 1.

Choose a Dynamic Angle for the Subject

What better way to add punch to an image than choosing an angle that "grabs" the viewer immediately? Here, I wanted to further emphasize the ship's preeminence over every scene in which it's a part. As a **com-** **position** technique, finding the appropriate angle from which to photograph is probably the most important element in putting it all together.

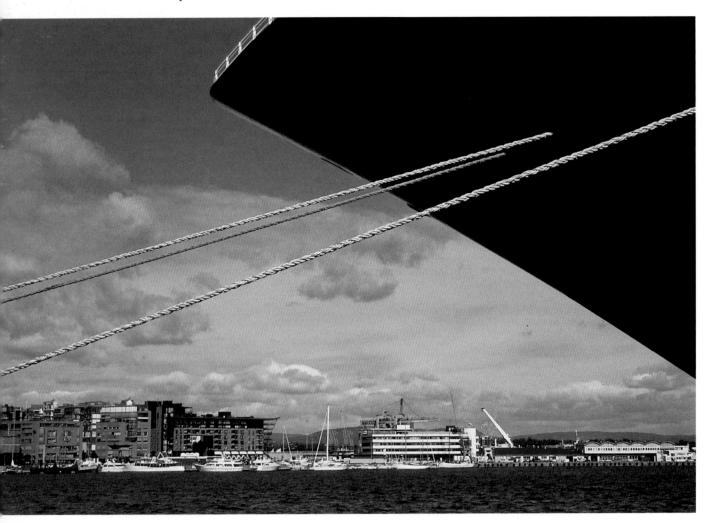

TEST YOUR EYE: COMPOSITION

Here is a group of images – decide first whether you feel the overall **compositions** are effective, then why or why not. My comments follow the images.

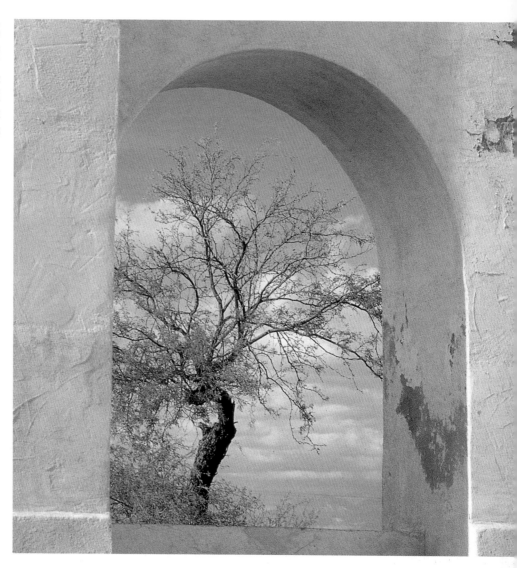

Frame 1. Location: Outskirts of ➤
Tucson, Arizona.

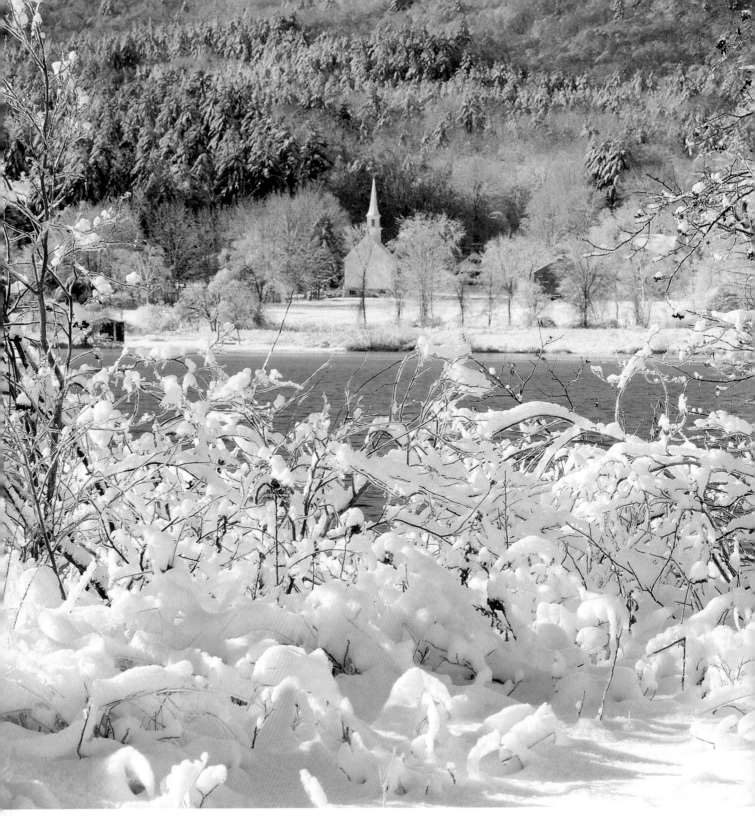

A Frame 2. Location: Crystal Lake in Eaton, New Hampshire.

Frame 3. Location: Sunrise from Clingman's Dome parking lot, Great Smoky Mountains National Park, Tennessee. Photographed with a Hasselblad 500mm lens on a Hasselblad 500 C/M camera body.

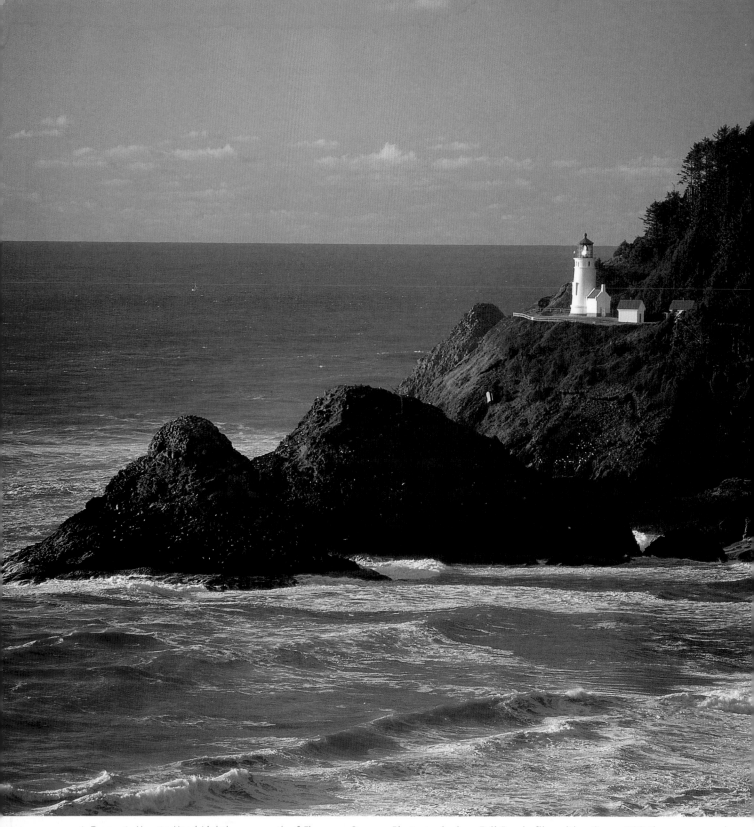

▲ Frame 4. Heceta Head Lighthouse, north of Florence, Oregon. Photographed on Fuji Provia film with a Canon EOS Elan camera and a Canon EOS 100-400mm Image Stabilizing lens.

My Comments

Frame 1

Simple framing leads to a clean, strong image. Void of distracting elements, the tree and the window opening complement each other and give the viewer a focal point.

Frame 2

Almost like Santa's beard, the white foreground provides a soft frame for the church in the background. The iced lake didn't add to the view, so it was excluded and the foreground instead filled with the snowy brush.

Frame 3

The combination of the soft colors, the "smoky" allure, and endless layers of mountains gives this image a classic look.

Frame 4

This doesn't work for me – too much sky, no action in the water, and only one "strip" of interest. Instead, look at the frame below (frame 5) and compare how it is filled from top to bottom with elements of interest – the lighthouse at the top, the surf at the bottom. No horizon is cutting half way through, dull sky is almost eliminated, and a static composition is avoided.

< Simple framing leads to a clean, strong image.

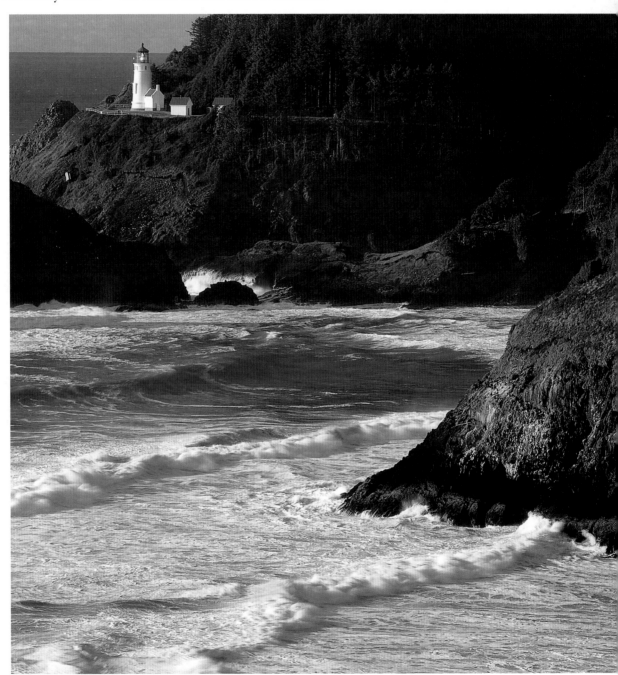

Frame 5. ➤

"ON THE SCENE" WITH COMPOSITION CHALLENGES

Bland Elements

What do you do when your subject is distant, with miles of dull foreground, like the gray beach scene I'm hiding in frame 1? Minimize it. I filled the foreground with driftwood, concealing most of the monochromatic sand. I provided just a small square to peek through to Haystack Rock, giving a frame of reference to the viewer. My lens is parallel to the driftwood to keep the entire plane sharp.

Invisible Hot Spots

Not quite sure if enthusiasm is outpacing your discipline? If colors, forms, or leading lines overwhelm me, I may not pay close attention to problems lurking in the frame. To overcome the problem, try unfocusing the lens completely. This abstract view will allow you to test your overall composition and detect hot spots, such as the bits of glare seen here on the tulips (frames 2, 3).

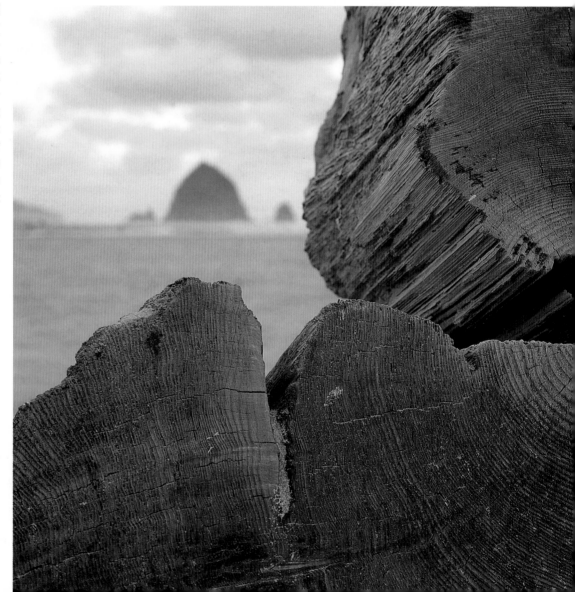

Frame 1. Location: ➤ Haystack Rock, near Cannon Beach, Oregon.

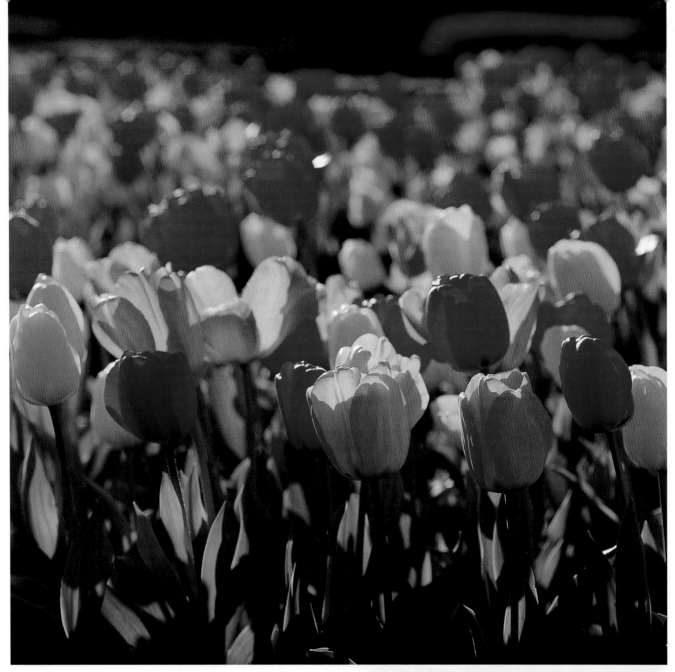

A Frame 2. Invisible hot spots lurking in the frame can present an easily missed problem.

Frame 3. Hot spots and overall composition may be easier to ➤ evaluate when viewing the scene through the unfocused lens.

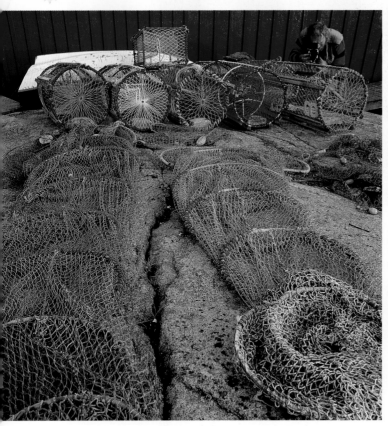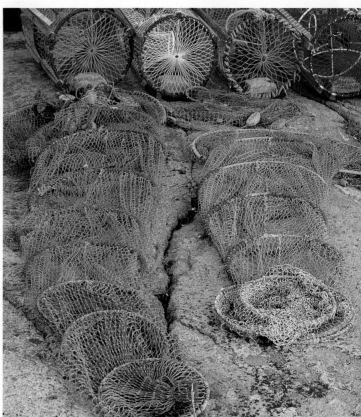

⋏ Frame 4. (left) Concentrating too much on the foreground can make it easy to overlook distracting elements in the background. Location: Swedish harbor.

⋏ Frame 5. (right) Recomposing the photograph creates a cleaner image, free from distracting elements.

In the second example (frames 4, 5), my concentration is all on the foreground, working on enough **depth of field** to lead you into the nets and traps. Yet the background distracts – both the white boat and the other photographer can be eliminated without hurting the **composition**. The end result is a cleaner, less confusing and better-organized image.

Uninteresting Light

What should have been an "A-ha!" moment to stop and photograph resulted in an "Oh no!" problem of dull light. The first image (frame 6) shows the light as we found it. I liked the compositional elements with the road leading to the spires and mountains in the background, but without black and white film to emphasize only the tones and compositional elements, the scene was dead.

To the rescue was a small pack of filters, found in any camera store usually in two sizes up to 3.5" by 5", for use in a holder on the front of the camera. I use the larger ones, not always in a holder, to quickly see the effect in the viewfinder. In this case, I discovered the **sepia filter** gave just the unusual look I wanted (frame 7), preserving the composition I had in mind and improving the light to make the image a "keeper" and not a "throwaway."

Frame 6. (opposite, top) The dull ➤ light in this scene didn't do justice to the otherwise solid composition. Location: View toward Turret Arch and the LaSal Mountains, Arches National Park, Utah.

Frame 7. (opposite, bottom) Adding ➤ a sepia filter created the unusual look I wanted.

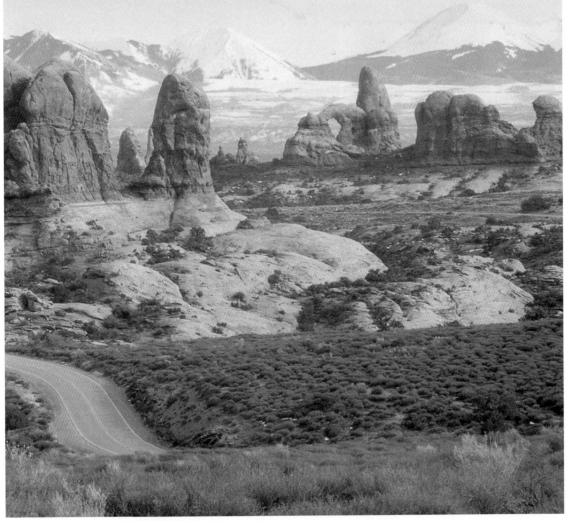

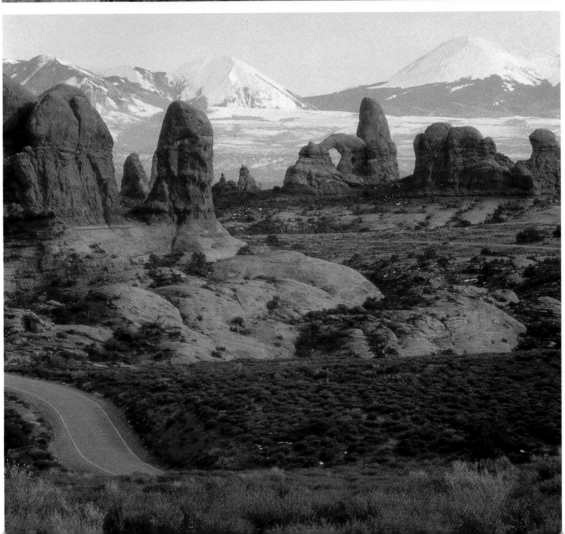

Too Many Beautiful Subjects

Fall foliage, fields of flowers... many times the patterns, colors, or design elements are mind-boggling. First, I take some pictures of the overall scene (frame 8), then narrow it down as I start to concentrate on what naturally appeals to me (frames 9, 10). I sift out the important from unimportant shapes. I allow plenty of time to work through the "how will I capture this?" mental block in order to slowly arrive at the images which will inform the viewer of my point of view.

∨ Frame 8. I begin by shooting photographs of the overall scene. Location: A tulip field in March, north central Oregon.

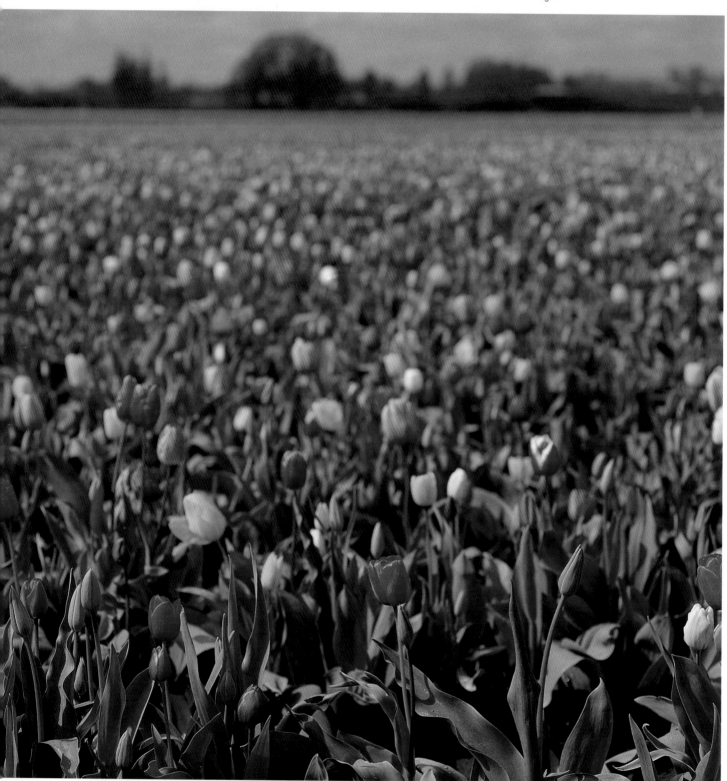

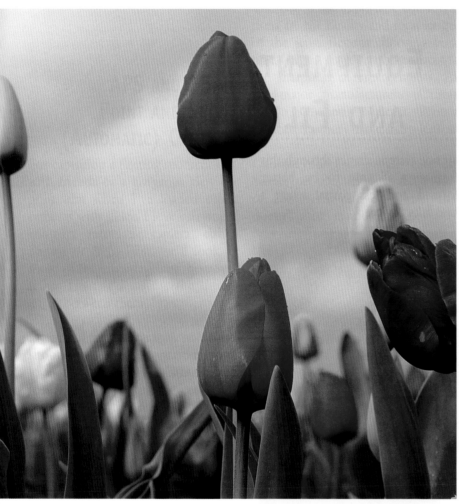

ʌ Frame 9 (above) and frame 10 (right). After making a few images of the overall scene, I begin to isolate elements of the scene which appeal to me. These images were photographed with a Hasselblad 503CW camera with a CF 120mm lens. For frame 10, I used a panorama mask.

can consult the index print without ever having to touch the negatives. All the major camera manufacturers produce beautiful APS cameras. Some top of the line models use the autofocus lenses you already own.

• Advantages

APS cameras are easy to load and offer a low cost for one-time use models. The cameras can be very small in size (depending on the model), and an index print comes with each processed roll. Color negative and black and white films are available. Upper-end models can use lenses from the 35mm systems. There are many competitors in the market with a wide variety of zoom options and other features. Three formats are offered on most cameras: "C" for Classic (typical prints in the 3.5 x 5 or 4 x 6 inch size); "H" for Group (typical print size 3.5 x 6 or 4 x 7 inches – the same ratio as High Definition TV), and "P" for Panoramic (typical print size 3.5 x 8.5 to 4 x 11.5 inches).

• Limitations

APS cameras have somewhat smaller negatives which is not a factor if you will only be making enlargements of 8x10 inches or smaller. It is not quite as easy to find processing for APS film as 35mm, and no slide film is currently available. Some models have a tiny viewfinder.

• What to Look For

Check out different size cameras to find the one that fits your hand, your pocket, and your pocketbook.

Evaluate the **zoom** length and lens quality. The 35-100mm range will allow you to shoot from **wide angle** to moderate **telephoto** images – appropriate if you plan on photographing both people and distant subjects. If you will be photographing primarily people, opt for a shorter zoom lens in the 35-80mm range or a fixed focal length, which may give the highest image quality.

Look at the location of the flash and fill options. You want the flash as far from the camera lens as possible to reduce red-eye.

Other features to look for are titling options (allowing you to add the date, time, picture title, etc. on the final print), a self-timer, water resistance and a case.

◄ If you will be photographing primarily people, opt for a shorter zoom lens.

35MM AND MEDIUM FORMAT SINGLE LENS REFLEX (SLR) CAMERAS

For many of you reading this book, the attributes of a single lens reflex system are clear. It's probably what you now own. "Single lens reflex" simply means that one lens is used for both focusing and exposing. With a twin lens reflex camera, in contrast, two lenses work together, but one is for composing and the other actually exposes the film. Twin lens reflexes aren't as popular as they used to be, so we'll only discuss SLRs.

35mm SLR

When the photographer desires more options than a point and shoot can offer – whether in lens selection, accessory choices, or exposure control – the move is to an **SLR** system. When people ask me what the "perfect system" is, I say it is different for each of us. Here's why:

• Some people prefer an abundance of technology in their cameras, while others are looking for a lower price. Some photographers will

use their cameras mostly on "program" or "auto," while others want complete manual control all the time. Some want a strong flash built in, while others never use it.

• Lenses are another personal choice. Your lenses reflect your interests, just as mine do. Sometimes I like to photograph close-ups, requiring a **macro lens** or **close-up filters**. Other times, I want to photograph mountains with a long **telephoto** to pull in the detail. You may prefer people in your images – or spiders, or interiors of houses. Your lenses should be compatible with your work.

So the "perfect system" depends on how you answer the following question:

• What *can't* you do with your current system that you want to do? If your answer is no more specific than "take better pictures," don't buy a thing. All you need is a good grounding in **exposure** and **composition** basics, and a thorough understanding of the capabilities of the equipment you now own. With this, you will get superior results. Think of it this way: it wasn't the brand of typewriter Hemingway used that made him a great writer, nor was it the logo on Monet's brushes that made him a master.

However, if your answer to the question is, "I can't take pictures at 1/1 magnification," or "My lens aperture when wide open doesn't allow a shutter speed fast enough for sports," or "I'd like more metering options," then read on.

Frame 1. A wide angle lens, such as this 50mm medium format lens (about 30mm in the 35mm format), can be used up close to a subject to show excellent detail in the foreground and great depth of field in the background. Location: Oregon coast.

Cameras

I think most photo workshop leaders would agree with me that avid amateurs buy the "best camera they can afford" instead of the best camera for their interests and abilities in the near future. It's easy to be oversold by camera companies who position their products in such a way that if you are "this good'" you feel you need "this camera." It's also easy to be persuaded by a love of current technology, thinking the camera itself will solve all of your exposure and composition problems.

Half the features on top of the line **SLR**s go unused by the majority of photographers. For reducing weight and cost, look for a camera that feels great in your hands, has the features you'll use, and the lenses/accessory line you like. If you want all the features on your camera to work with your lenses, be sure to buy both from the same manufacturer.

Lenses

What are the subjects you are drawn to? My personal preferences for matching up lenses and subjects fol-low. Keep in mind that if you ask ten pros, you will get ten different responses. It's a good idea to study work you like and go from there.

1. Scenics with Foreground Emphasis (28mm lens)

When your aim is to show the environment in which you found the scenic subject, move in tight on a foreground object (frame 1, previous page). Then use lots of **depth of field** (shooting at f/16, f/22) and "tell a story with one image."

2. Scenics Without Foreground Interest (100-400mm lenses)

I do *not* use a wide angle lens for most scenics. Instead, if all the detail is at infinity, such as in the images on page 70 and 77, I use lenses in the moderate to longer telephoto range to bring the scene closer and eliminate unnecessary objects.

3. Animals in Captivity (70-200mm)

Animals in captivity seldom require long lenses. The shorter the focal length, the easier to work without a tripod, too. Shallow depth of field should blur most barriers, and a shutter speed 1/125th and faster will stop most motion.

4. Animals in the Wild (200-600mm)

Animals in the wild warrant the longest lenses and most working distance you can give them. Your pictures will be more natural and the animals won't be spooked. In parks, you often cannot step off the boardwalks or approach wildlife within 75-100 feet. If you are in low light without a **tripod**, use faster film.

5. Sports (200-600mm)

Here's where the 400mm, f/2 and 600mm, f/4 lenses reside. Motion, low light and distance from the subjects make these containers of heavy glass a necessity.

6. Close-ups (50-100mm Normal or Macro)

First, how much magnification do you want to achieve? For low magnifications, you may not need a

⋁ Frame 2. For low magnification, close-up filters are an economical choice. Location: Katmai National Park, Alaska

specific **close-up lens** other than a zoom you already own, in the 35-135mm range. If you want to fill the frame with a maple leaf, for example, you will not be magnifying the subject much, so invest in **close-up filters** that do not reduce the light reaching the film, are light in weight, and cost much less than extension tubes or a specialty lens (frame 2).

On the other hand, for very small subjects, life-size magnification may be important. "Life-size" means that the subject records at its full size on the film – if the subject is half an inch long, it records that size of your film. For this higher degree of magnification, either invest in a macro lens that achieves "1/1" or in extension tubes to accomplish from $1/10^{th}$ to full life size (generally the definition of close-up photography).

If you choose to use **extension tubes**, which are placed between the camera body and lens, how many tubes and what length (measured in millimeters) will you need? It's easy. If life-size in the goal, you will need the millimeter of extension equal to your focal length. If your lens is a 50mm lens, then, you will need 50mm of extension. Tubes reduce the light reaching the film, but your in-camera meter should take that into account. You should be working on a tripod, so a slow shutter speed will not be a factor unless your subject is moving. Use a cable release.

Remember that a ladybug at life size is still only a quarter of an inch across. To fill the frame, she would have to be at least four times life size! This means achieving 4/1 representation, which can be accomplished using multiple extension tubes. You will probably be almost touching the bug at this point.

If close-up photography is your passion, you may buy a macro lens to

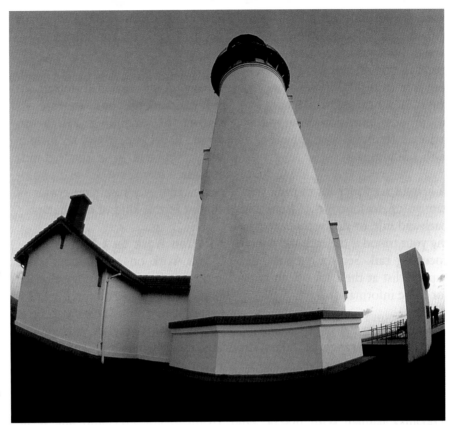

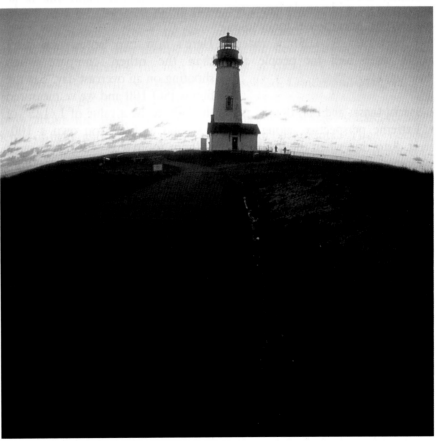

⋏ Frame 3 (top) and frame 4 (bottom). Extreme perspective (along with great distortion when the horizon is not centered) can be achieved with a fisheye lens. Location: Oregon coast.

DIGITAL CAMERAS

If you own a computer and a color printer, a new world opens up if you "go **digital**." Just as slow and fast films serve different purposes, "filmless" cameras fill a niche and offer interesting possibilities.

When someone says "digital picture," you may think of noticeable dots, grain, and poorer quality than a photographic print – but that's history, even for the moderately priced cameras ($300-$800). Frames 1 and 2 are images from my mid-priced Kodak digital camera with nice detail and color.

The major difference now between film cameras and digital cameras is the medium upon which the image is captured, and who does the "processing." Instead of film, the digital camera uses a card or floppy disk to record the picture. The software to see, enhance, and print the image from your computer is included with the package.

This leads to part of the fun of digital photography – the immediacy of the gratification! Not only can I see the image on the back of the camera a second after I take it, but I can bring the image up on my computer a moment later by inserting the memory card into my computer's PC slot. Once I see the images, I can then download them onto my hard drive and free up the space on the camera's memory card to use it over again. The cards are like reusable rolls of film. You can buy cards from 8MB (megabytes) of memory to 80MB of memory. Loosely, this translates to between 20 and 150 images on the Best Quality setting.

You are in charge of "processing" – instead of heading to a photo lab, you go straight to the computer and either connect the camera to the computer directly, or take out the "flash card" or floppy from the camera and insert it into the computer or an external drive. Then, using the software that came with the camera, it is an easy step to crop or enhance the image – or simply print it right off a color inkjet printer. I use Kodak, Hewlett-Packard, plain or Avery papers made for color inkjet printers.

Frames 3, 4 and 5 show an example of two digital images combined for a family card. The ability to quickly retouch and/or composite images is another attractive feature of digital photography.

Close-up attachments, wide angle and telephoto add-on "lenses" and exposure compensation are available features on many models.

• Advantages

On many models, digital cameras allow for instant viewing of the pictures on a display on the back of the camera. You can keep (or delete and retake) the image right then. This means you'll always know that you got the shot before you walk away. Going digital also means no more

⌄ Frames 1 and 2. Gone are the days when digital cameras were a novelty that produced dotty, grainy images. Today, even moderately priced models produce clear, sharp photographs.(Left, Storyland, Glen, New Hampshire. Right: Kristy Andrews.)

trips to the film shop or the lab. Each floppy or flash card is re-writable, so you can take the pictures, download the images onto your computer's hard drive, delete the pictures from the card and use the card again.

• Limitations

Digital cameras are generally more expensive than APS or point and shoot SLR cameras. They are really minicomputers that take pictures. Digital cameras run through batteries quickly if you frequently look at the pictures you just took. The imaging cards are also expensive, although you only need one or two. My camera came with a 16MB card, which takes about thirty pictures on highest resolution and costs about $50 if bought separately. If you want to enlarge pictures beyond your printer's capabilities, you'll still need to take a trip to the lab.

• What to Look For

Look for an auto focus feature, and the highest image resolution you can afford. I'd recommend at least a million pixels. Decide on a fixed focus lens or zoom. Look for a lens ratio of at least 2:1 – ignore the digital zoom numbers. Consider the exposure controls (automatic or some manual override), flash range to about ten feet and flash features such as automatic, fill, red-eye, and off options, and the removable memory using either a flash card or floppy disc (I recommend the card). You'll also need to keep in mind the computer

Frame 3 (top). A family portrait is ➤ missing one member who was present in another photograph with a girl-friend (frame 2, center). To complete the family, both images were loaded into a computer, and the daughter's image removed and pasted into the group. After rotating her a bit and "cloning" her blouse to rebuild her right shoulder, the family portrait was complete. (Top (L to R), Bert, Mark, Erik, Cindy and Kristy Andrews. Center (L to R), Heather Perrier and Kelly Andrews.)

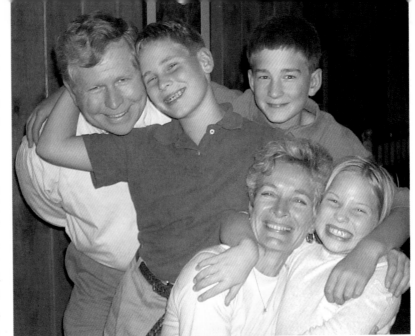

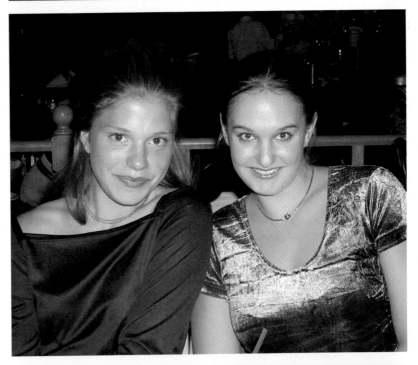

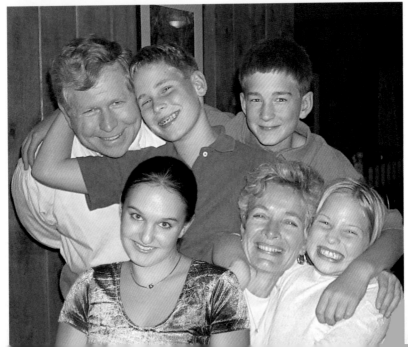

you want to use the camera with and what features are required, as well as its platform (Mac or PC compatible). Find out if a power adapter and rechargeable batteries are included, and, if it's important to you, if text/date/time imprint is featured. You can download information from camera manufacturers' web sites and compare features.

• Frequently Asked Questions

1. Do you have to buy a digital camera to get pictures on the computer?

Not at all. You have many options for putting pictures on your computer for e-mail, letters, and so on. The least expensive method would be to check the "CD" or "floppy" box when you have your APS or 35mm film developed. Your pictures will come back as prints and also stored on CD or floppy to insert right into your computer.

With APS film, you can also buy an external drive to insert your processed film (no CD or floppy required) and see your pictures on your computer screen.

In addition, you can scan your photos. Inexpensive scanners for prints and slides (usually with an adapter) run $200-400. Check the price, the ease of use, and the flexibility of each option to help make a decision.

2. What kind of computer do you need to effectively store and work with digital images?

Pentium II or similarly fast processors with as much storage space as possible are best for digital imaging. Scanners and digital cameras work with older systems as well. Digital files are large and take up a lot of RAM to use, and a lot of storage space on the computer to archive. I suggest a CD-ROM drive, a floppy drive, and a PCMCIA (PC slot) for a good system. Better yet, buy a CD writable drive to store your pictures on CD, or to make CDs of your pictures to send to friends.

< Digital files are large and take up a lot of RAM to use.

FILM SELECTION

You don't choose your photo destinations in a vacuum, so why pick one film and ignore the other eighty on the market? Your answer is probably like mine – when learning photography, we were encouraged to "find a film you like and stick with it." That would be a pity today. Even though the number and types of film on the market are overwhelming to evaluate, it's not difficult to narrow down films for different purposes.

Slide or Print Film?

Tell me the end "product" you want, and the type of film becomes obvious.

If you are photographing to put beautiful images on your walls, or in a photo album, or to give away candids after a family event or trip, use print film. The negatives are much easier to work with for enlargements and reprints – and you have a great deal more exposure latitude in the field. Your exposures can be off by three stops on the **overexposure** side and two to three stops **underexposed** and come out looking acceptable. With slide film, you have only a half stop on either side (under- or overexposure) before your images are throw-aways. The pros find more than even a third of a stop unacceptable for slide film.

If your images are to be used in slide shows, magazine articles, and books or sold to stock, it is best to use transparency film. Unfortunately, many people file their slides away and never bring them out again. Whether you use print or slide film, your overall cost in the long run will be almost identical.

Film Speed
•Slide Film

"The lower the number, the finer the grain." Although this is still true, it's more difficult to discern every day. With the just-released **ISO** 100 slide films, you would be challenged to find the difference in **grain** with an ISO 50, even on a ten-foot screen.

Therefore, I recommend an all-purpose ISO 100 for slides, pushable up to two stops to ISO 400 in a pinch. In the image on page 98 (frame 2), however, I saw the light leaving us in the late afternoon and inserted a roll of ISO 400 film in the camera for the fox image. I **pushed** Fuji's RMS 100-1000 to 1000 for the image on page 36.

•Print Film

Since print film usually isn't pushed, choose a speed for the occasion. For bright light or subjects within ten feet in flash situations, I suggest ISO 100 or 200. Their grains are very similar. Many people keep ISO 200 in their camera all the time.

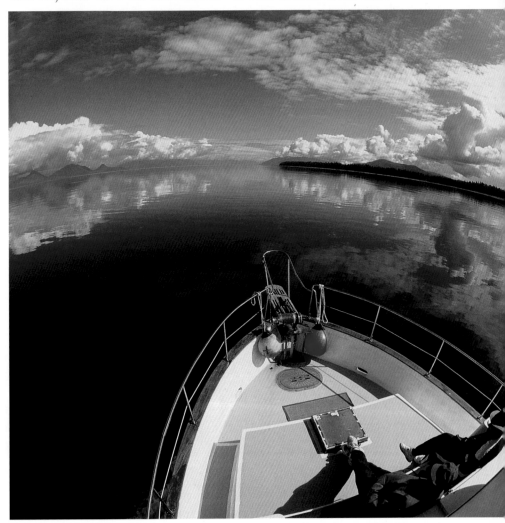

Frame 1. My favorite sunny day films are from Kodak's line of E100 slide films and Fuji's Provia. Here, I used E100S, working hand held for a fish-eye photo aboard the 50-foot Delphinus on Alaska's Inside Passage. The image was created using a Hasselblad camera with a 30mm lens and a sunny day exposure of 1/125th of a second at f/16 (unmetered).

△ Frame 2. I used Kodak's ISO 400 film for this late afternoon image. Subject: A red fox wildlife model photographed in Chittenden, Vermont.

When I teach on cruise ships, I see a trend of passengers using ISO 400 all the time. At first I thought this was misguided marketing advice, but now I see the logic. Most people do not enlarge past 5x7, so grain is not a factor. On one roll of film there are often a wide variety of subjects and events – sometimes images from Christmas to Easter, indoors and out, in low light with and without flash, bright sun pictures, and so on. Photographing with ISO 400 allows this latitude in lighting conditions and still produces great images.

A faster film works better in a wider variety of conditions. If camera shake

is a real concern – not just by the photographer, but also by the nature of being on a ship, in a bus, or in a car – the faster film allows faster shutter speeds and therefore helps make sharper images in unsteady or low light conditions.

What about even faster films? ISO 800, sometimes called 800Max by Kodak, is a film offering more than just speed – the images are well saturated, sharp and impressive. For very low light without flash, for moving objects, or shaky surroundings, it saves the day.

Also try a black and white film called Kodak T400CN (for color negative) that you can have processed in color chemicals for one-stop print processing. For everyone who has avoided black and white because it takes too long to process (when you can find a lab to do it), T400CN is the answer. I use this film when friends want black and white candids or if I want to hand tint for an unusual effect.

Green Box or Yellow Box – Does the Manufacturer Matter?

All the name brands sell impressive films, though people ask the differences between Kodak and Fuji most often. Traditionally, Fuji sold more saturated films, rich in colors that popped off the paper. Applications would include clothing photography, landscape, nature and wildlife work, and stock photography. Kodak historically specialized in "accurate" films that neither over-nor undersaturated the colors present – particularly appropriate for facial tones, wedding applications, studio work, and catalog photography. Now, both companies offer many products in each category – with the major difference where the films are made. Kodak produces its film in Rochester, NY, and Fuji makes theirs in Japan. Their print films cost almost exactly the same. Visit their web sites, as noted on page 33, for current information.

• Professional or Consumer Film
The "Professional" labeled film is meant for immediate use, whereas the "Consumer" film matures over time – a little like a ripe banana compared to a green one. It is to your advantage to use the "Consumer" film if you often leave a roll of film in the camera for any length of time and do not want to refrigerate your unused film. The consumer films have a little more contrast and color punch to them, along with lower prices.

Film Questions I'm Often Asked:
• Where do you get your film processed? I'm a little picky here. Many one-hour processors are great, but I look to see if they run the chemicals of the film I'm using. For example, if my film is Kodak, I'd prefer a Kodak lab, not one using Fuji chemicals. If for any reason you notice an overall color shift to reddish, bluish, or greenish, ask to have all your prints rerun to have the color removed. You will notice the shift most in the light areas and in facial tones.

• How much film do you bring on a trip? I might shoot five rolls one day and eight the next, but I bring enough film for ten rolls a day. I don't like to buy film in foreign countries because it's expensive and I don't know how it's been stored. Almost all the film I shoot is slide film, with a few rolls of print for the point and shoot. The speed is almost always ISO 100.

⊰ Many one-hour processors are great, but I look to see if they run the chemicals of the film I'm using.

Exposure:
Are You in Control?

No doubt you are comfortable with more than 75% of exposure situations. It's the extraordinary light that informs whether you are really "right on," though (frame 1). Can you capture the light the way you wanted it, time and time again? I often tinker with exposure in half and full stops, but it's more to see what the film can record that I can't imagine. Your "signature" images (frame 2) result from a comfort with the exposure part of photography. Then, you can concentrate on the feel of the scene, the composition, and capturing your personal vision. My rule of thumb for light tones is to record them as light as I can, while still retaining detail in the highlights.

⋀ Frame 1.

▲ Frame 2. At -27°F, who wants to waste precious time and energy making tens of images to guarantee a good exposure? Practice will help you get it and go. Location: Mud Volcano boardwalk, before Sizzling Basin in Yellowstone National Park.

COMPOSITION

Have you designed the image or simply shot it? All the tips and techniques previously detailed lead you to designing a balanced, dramatic image (frame 1).

Can you now move from these guides to modifying the rules to express your unique style? Maybe filling the center of the frame with the subject to emphasize it? Choosing your longest focal length to pull in the landscape (frame 2)? Using an offbeat lens to show expanse (frame 3)? Aiming directly at the sun for effect (frame 4)? Instead of the "rule of thirds," are you now moving toward organizing the frame in a way that makes the viewer get beyond the border of the scene, providing tension (frame 5)?

Thinking "outside the box" works when the composition guidelines are second nature. Move away from "safe" compositions to stretch your portfolio of styles.

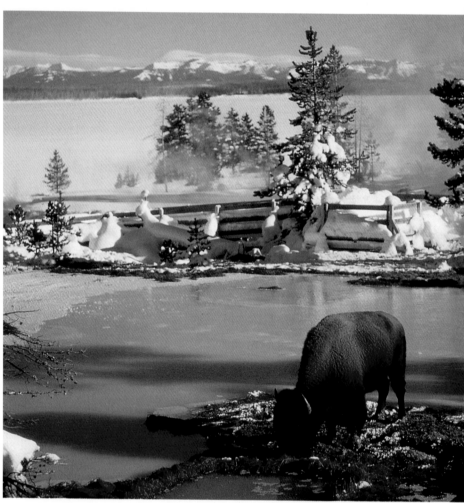

▲ Frame 1. For a winner most every time, lead the viewer's eye into the frame with a strong foreground subject, such as this bison. Location: West Thumb geyser basin on the edge of Yellowstone Lake.

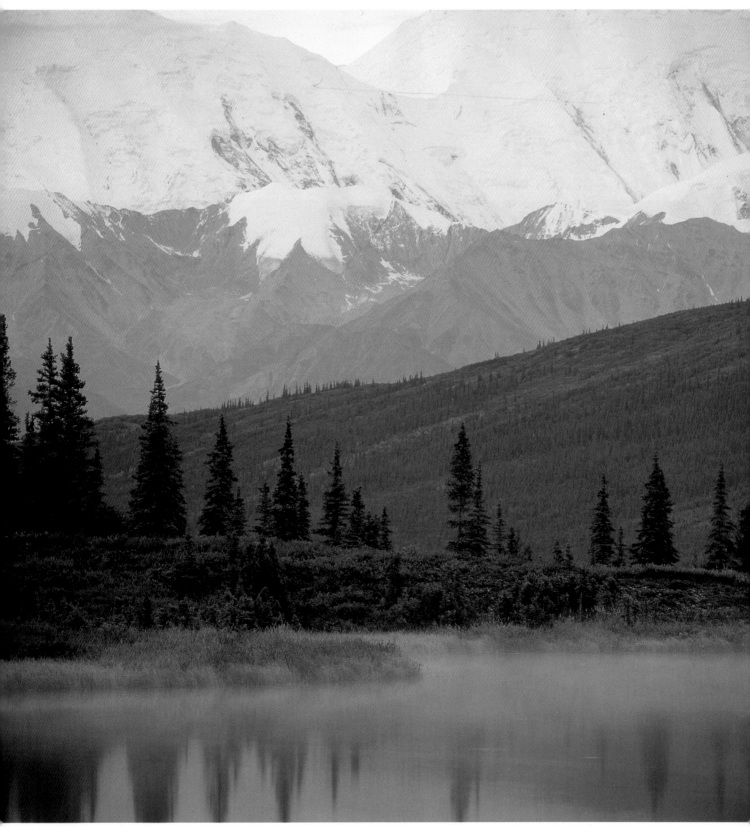

A Frame 2. Squeeze the scene into the frame by choosing a long lens. I made the image on Fuji Provia film using a 500mm medium format lens. Location: Wonder Lake in Denali National Park, Alaska.

⌄ Frame 3. Using an unusual lens (such as the 30mm medium format fisheye) helps convey the expanse of this scene. Location: Alum Creek in Hayden Valley, Yellowstone National Park.

Frame 4. Pointing directly at the sun, using an aperture of f/16 or smaller, created the starburst effect to enhance the composition. Location: Backcountry Trail near Snow Pass in the Mammoth Hot Springs Area, Yellowstone National Park, Montana.

∨ Frame 5. A "normal" lens, tight organization and cropping to a panorama format are all that are needed to create tension and encourage the viewer beyond the borders of this image, taken on a Hasselblad camera with a 120mm medium format lens. Location: Nugget Pond at Camp Denali in Denali National Park, Alaska.

EQUIPMENT

Is your camera and its accessories helping or hindering you?

You could just as easily be carrying around too much equipment as too little. Become more spontaneous and mobile in your everyday photography by paring your gear down, making it easily accessible, and making what you have work extra hard. You can crop, chop and enlarge when you get the results back.

I have a friend, Elaine, who challenges herself each week to photograph for an hour or two near home, taking a single different lens with her each time. It forces her to make all the images with this lens – instead of falling back on how she "normally" shoots with wide-angles, normals and telephotos. The following images demonstrate examples of this exercise, showing the flexibility and variety possible using one lens in different situations.

ⓥ I had the "wrong" lens on my camera as I noticed the clear reflection on Wonder Lake, and a duck swimming across to shatter the effect. Using a barely-telephoto 120mm medium format lens, I made three images. When I got home, I cropped the images to a panorama to eliminate much of the sky and water.

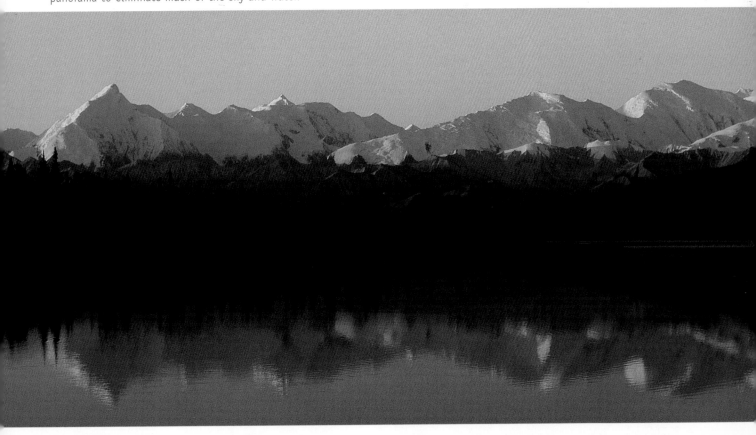

Simplify, Simplify

I think we all know we would use our equipment more often if there were less of it! For around town or "on the fly" photography, put one lens on your camera and photograph what you see, in all seasons. The following are four examples using only my 120mm medium format lens (take 60% of the medium format length to determine the equivalent 35mm format).

⌄ This image of Hans Christian Andersen's hometown of Odense, Denmark, was photographed while taking a morning walk with friends. I stopped for some quick images with my Hasselblad camera and 120mm lens. I saw the composition before I stopped and took a quick meter reading from the orange-colored building.

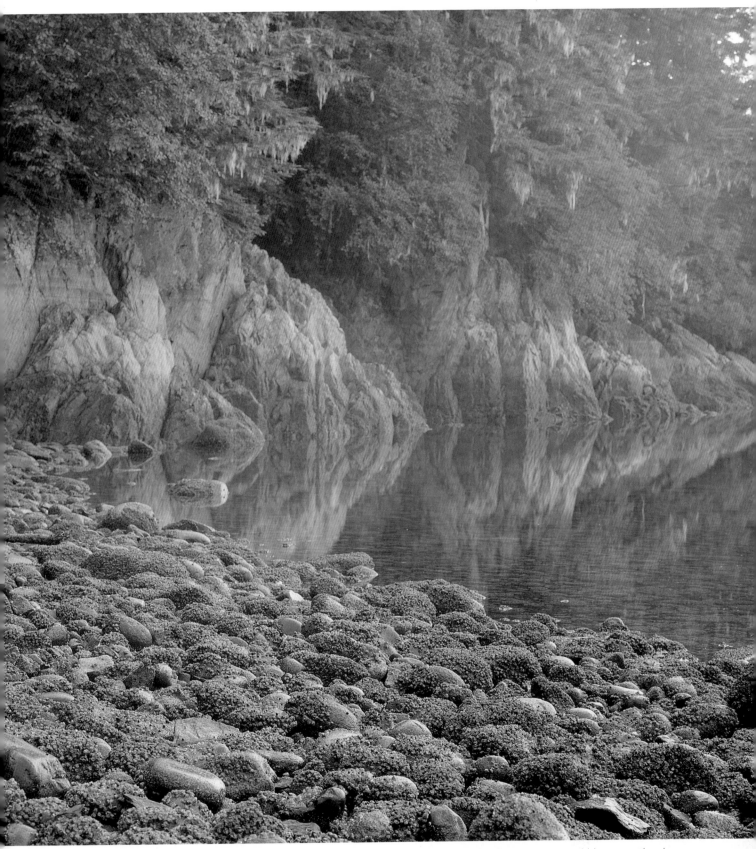

A You can bet I didn't have much time to fiddle with a camera bag and tripod while staying in a group to avoid bears on the shoreline of Alaska's Inside Passage. When this muted, reflected scene caught my eye, I slowed down and took the Hasselblad camera, mounted with a 120mm lens, from around my neck. I read the meter from the gray/green area, while thinking about the composition to include the rocks' texture in the foreground.

Less is More

When I'm carrying a heavy camera bag for a long distance, loaded to the gills with a large variety of lenses and accessories, slowly (and at first, unnoticably) I become drained of enthusiasm, creativity and energy. Now, when I'm hiking, or skiing, or walking more than a half mile, I reduce my equipment to the basics and start "tinkering" with the scene using the gear I have. When at home, I leave a camera set up so I can grab it at a moment's notice.

⩒ A three hour walk on the beach produced interesting images almost constantly. For the walk, I packed a tripod, a Hasselblad camera body, a 50mm wide angle lens, a normal/telephoto lens (120mm), a cable release, a couple of filters, lens hood, and six rolls of film. For another example with this same bag of equipment (particularly the 120mm lens), see page 80. Location: Coquille River Light, Bandon, Oregon.

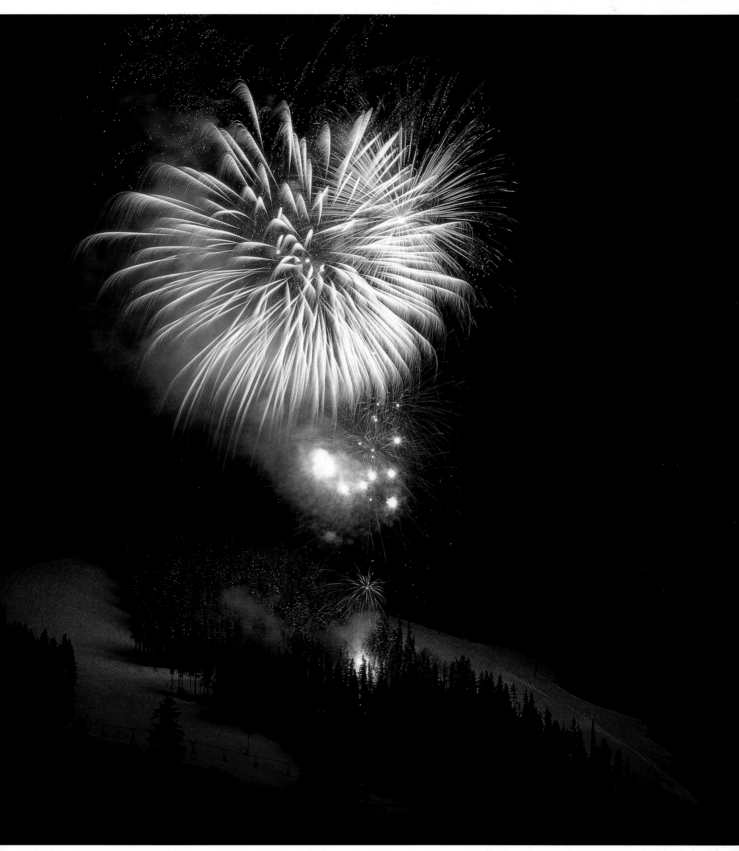

A This spur of the moment image was made after I heard the initial blasts announcing these winter fireworks at the ski resort of Beaver Creek, Colorado. In five minutes, I was set up and firing away. For fireworks, set up your camera with a moderate to long telephoto lens at f/11 or f/16 on a tripod or deck railing. Then attach a cable release, and move the lens to infinity and the "bulb" setting. Then keep the shutter open for 4, 6, 10 or 15 seconds (or whatever will capture the number of bursts you desire in the frame).

In Conclusion

Most authors ask you to be critical of your work in order to improve. I'll request you also enjoy where you are in your photography.

Like anything else, you'll always find people "better" or "not as skilled," but the real goal is to express your unique view of the world – which only you can do. It's not our similarities as photographers that make us stand out, it's our differences. Work on what makes your vision different from mine.

I firmly believe once you have mastered the basics in this book, you will set your creativity free. How can a composer write an original score without understanding notes and instruments first? Analogies abound.

But don't be too hard on yourself about the speed of your progress in the meantime. Whenever I feel my work is not moving along fast enough toward some unseen point, I make myself look at photographs from a few years back. Then, comparisons with other people, with where I "should be" – all those unproductive emotions – simply vanish.

I hope you will do the same and enjoy your photography, and the outdoors, for a lifetime.

◅ It's not our similarities as photographers that make us stand out, it's our differences.

GLOSSARY

Ambient Light, *see* **Available Light.**

Available Light
Available light is all of the light which exists naturally in a scene without supplement by the photographer. This could be sunlight, light from a lamp, candlelight, etc.

Bracketing
Bracketing means photographing an image more than once, slightly varying the exposure each time to maximize the chances that at least one frame will be properly exposed.

Cable Release
A cable with a plunger at one end and threads (or electronic connectors) at the other end which attaches to the camera's shutter release. Depressing the plunger trips the shutter without the photographer touching the camera. This eliminates camera movement that may lead to blurred images.

Center Weighted Metering
Center weighted light meters give preference to the frame's center. If it is occupied by something much darker or lighter than the rest of the the scene, this can cause the meter to suggest an exposure which will not be accurate for the overall scene.

Classic Format
This is one image format (with typical print in the 4"x6" or 3.5"x5" size) generally offered on APS cameras and the normal image format for 35mm images.

Composition
Composition is the careful arrangement of subjects within the frame of the photograph to produce an effect or communicate the photographer's message about that subject.

Close-up Filters
Close-up filters, used singly or in multiples, allow a lens to focus at less than its normal minimum focusing distance.

Contrast
Contrast is the difference between the darkness of one tone and another. High contrast occurs when there is a great difference, such as the difference between black & white. Low contrast occurs when there is little difference, such as the difference between medium gray and light gray.

Cropping
Cropping is trimming the edges of the frame, usually to improve the composition. This can be done before taking a picture (by changing

the camera position or lens), or during the printing process.

Depth of Field
The depth of field is the area between the farthest and closest points from the camera that is in focus. Depth of field is controlled by the aperture.

Diffuser
A diffuser, either a filter, or often a piece of sheer mesh placed over the lens, produces a soft image with diffused details.

Digital Cameras
Instead of film, digital cameras use memory storage devices, such as floppy discs or flash cards, to store images. The images can be directly transferred from these storage devices to a home computer to be stored, edited or printed.

Exposure
Exposure governs the amount of light allowed to fall on the film. Specifically, it is the intensity of the light, controlled by the aperture (or f/stop), multiplied by the duration of time the light hits the film (controlled by shutter speed). *See* Under- and Overexposure.

Exposure Value
Exposure value describes the total amount of light hitting the film. The same value can be achieved using a number of combinations of apertures and shutter speeds.

Extension Tubes
Extension tubes are hollow metal rings that can be added between the lens and camera body to allow for close-up work. They move the lens farther away from the film plane, allowing the lens to focus closer than normal.

Fill Flash
Fill flash is flash light used to supplement the main light source in a scene, such as the sunlight outdoors. It can be effective when photographing subjects that are strongly backlit, have deep set eyes, or strong shadow areas.

Fisheye Lens
A fisheye lens is a lens with an extremely wide angle of view which causes considerable distortion at the edges of the frame (which appear to bend in) when the horizon is not dead center.

Focusing Rail
A focusing rail screws on between the tripod head and the camera base, allowing the camera position to be adjusted without moving the tripod.

Full Flash
Full flash is flash light used as the main light source in a scene.

Graininess
Graininess is an increased appearance of the clumps of silver oxide on a negative, resulting in a speckled look in the print. Increased graininess can be a result of pushing film.

Gray Card
A card which reflects a known amount (18%) of the light falling on it. Metering from a gray card provides accurate exposure information in situations when the subject itself is not of average reflectance.

Hot Spot
Hot spots are areas of overexposure (very bright areas) in an image, such as spots of glare off water.

Incident Meter, *see* Light Meter.

ISO
A number which describes the sensitivity of film to light. The ISO doubles as the sensitivity doubles. ISO 200 film is twice as sensitive to light

as ISO 100 film, for example. Also referred to as film speed.

Light Meter
Light meters measure the amount of light in a scene and allow the photographer to select the appropriate camera settings which will result in correct exposure. There are two common kinds of light meters. *Reflected* light meters (the type found in most cameras) measure the amount of light emitted by or reflected off the subject. A spot meter is a type of reflected meter designed to measure the light reflected from a very small area, yielding a very precise reading of the settings needed to expose that area correctly. *Incident* light meters measure the amount of light falling on the subject.

Macro Lens
A macro lens is specially designed for taking close-up photographs.

Meter, *see* Light Meter.

Mirror
Useful for bouncing light into the shadowy areas of your subjects.

Neutral Density Filter
Neutral density filters absorb a quantity of all wavelengths of light, reducing the amount of light that reaches the film but leaving the color balance unchanged. A split neutral density filter allows a portion of the frame to remain at the current brightness (unfiltered), while toning down (filtering) the rest of the image. It is commonly used to balance a very bright element, like a bright sky, with a darker scene.

Overexposure
Overexposure occurs when the amount of light which hits the film is in excess of that needed to produce an accurate representation of the subject on film. The resulting print is lighter than desired.

Panorama
A panoramic image is three times as wide as it is tall (typical print size is 3.5 x 8.5 to 4 x 11.5 inches). A setting to shoot this type of image is included on most APS cameras and is also offered on some other 35mm and medium format systems.

Photo Discs
Fabric discs, which are either translucent, silver, black or white on each side, are available in many sizes, from compact to studio-sized. They are useful in place of fill flash, or to shield a subject from direct sun.

Pushing Film
Pushing film means to expose it at a higher speed rating than is indicated on the film. To compensate for the resulting underexposure, the film must be developed more than normal. Pushing film allows the photographer to shoot at lower light levels than would otherwise be possible.

Rangefinder
In a rangefinder camera, the image is composed through a viewscreen which looks over the lens, rather than through the lens via a mirror with an SLR camera.

Reciprocity Failure
Reciprocity is a theoretical relationship between exposure time and intensity of light which says that when one is increased, it can be balanced by a decrease in the other (i.e. doubling the aperture should be exactly compensated for by halving the exposure time). Unfortunately, this law does not hold up for very long or very short exposures. This is called reciprocity failure. Long exposures often suffer from underexposure unless the effect is compensated for. Generally, it is considered safe to make exposures between 1/10,000 of a second and ten seconds without worry of reciprocity failure.

ABOUT THE
AUTHOR

After growing up in Maine, Judy Holmes graduated from the University of Vermont with a BA in Anthropology and went on to graduate school at Dartmouth College where she earned an MBA from the Amos Tuck School of Business. Throughout her upbringing and education, Judy felt a close connec-

Photo by Greg Baer

tion to the outdoors. She loved the New England landscape in many ways – sports, nature hikes, fall foliage trips – and enjoyed life "up north" in all its seasons.

She always brought a camera with her on outings to capture the beauty she saw. However, she wasn't usually pleased with the results. When she decided to pursue a career in business (human resource management), she didn't work on her photography for several years. Instead, photography became one of Judy's hobbies – like identifying wildflowers, sewing quilts and running marathons.

During the years she worked in the business world, she continued to upgrade her photo equipment, hoping each new camera would take better pictures than the last. "How naive!" She says, "As if the brand of my calculator helped me in business!"

In 1988 a veiled opportunity presented itself; her husband sold his business and retired from the Boston business community, and Judy "retired" from Fidelity Investments to enjoy time with her husband. It was also a chance for her to take photography workshops and figure out this mysterious hobby that joined technology with art.

In the first year of their "retirement," Judy looked in the back of *Outdoor Photographer* magazine and signed up for four workshops in national parks with pros who wanted to supplement their income by teaching amateurs. The classroom

was the outdoors, and the subjects were everything from wading birds, to spider webs, to sunsets and alligators. She learned basic exposure and composition techniques and how to use her equipment to its fullest capability.

After a few of these week-long seminars, Judy realized that she needed practice before taking more lessons. A great by-product of the workshops was meeting other people who loved photographing the outdoors as much as she does. She travelled to destinations with these photo friends and practiced to her heart's content. Much of her advanced knowledge was gained on her own, photographing with friends, talking with them before and after the day's shoot, and reading everything she could get her hands on.

When she went into the photography business professionally in 1992, it was with a poster of Mount Washington, in New Hampshire. Judy now provides a number of commercial and editorial photographic products from postcards and notecards, to catalog and magazine covers. Her work is represented worldwide by AlaskaStock.

Teaching photography through magazine articles, books, lectures and workshops has also become a chief component of Judy's business. She has taught outdoor photography for Hasselblad University on Location for the past six years in fifty cities, and has appeared as a speaker for Hasselblad throughout the world. To enhance her platform skills, she joined the National Speakers Association, which she strongly suggests for all teachers. Judy has also served as an Artist in Residence at the Disney Institute and lectured on photography at numerous professional photographic trade shows, sponsored by film, clothing, camera and accessory man-

ufacturers. Additionally, she teaches travel photography aboard cruise ships, small boats in Alaska and to camera clubs and camera dealer groups across the country.

Judy's images have appeared in numerous publications, such as *The Boston Globe, Rangefinder, Popular Photography, Photo District News, Petersen's PHOTOgraphic, Studio Photography, Outdoor Photographer,* and *Professional Photographer* magazines, in addition to numerous calendars and books. She is also the author of *Eye on Nature: An Elegant Little Guide to Outdoor Photography,* published in 1996 and sponsored by Kodak, L.L. Bean and Hasselblad. In 1997, she authored Hassleblad's new brochure on close-ups.

In the course of her photographic career, Judy has traveled the globe, shooting such exotic subjects as the Iditarod mushing race in Alaska, Mt. Kilimanjaro in Tanzania, Norwegian fjords, St. Petersburg, the Berlin Wall, and bluefooted boobies in the Galapagos islands. Her favorite locations are the East and West coasts of the US, and mountains everywhere.

In the future, Judy sees herself becoming increasingly involved with photographic education. Having taught over 20,000 students in her career, she is particularly interested in reaching the "everyman" photographer. As she says, "Almost everyone in the country owns a camera and wishes he or she could take better pictures."

INDEX

Other Books from
Amherst Media, Inc.

Basic 35mm Photo Guide

Craig Alesse

Great for beginning photographers! Designed to teach 35mm basics step-by-step — completely illustrated. Features the latest cameras. Includes: 35mm automatic, semi-automatic cameras, camera handling, *f*-stops, shutter speeds, and more! $12.95 list, 9x8, 112p, 178 photos, order no. 1051.

Build Your Own Home Darkroom

Lista Duren & Will McDonald

This classic book teaches you how to build a high quality, inexpensive darkroom in your basement, spare room, or almost anywhere. Includes valuable information on: darkroom design, woodworking, tools, and more! $17.95 list, 8½x11, 160p, order no. 1092.

Into Your Darkroom Step-by-Step

Dennis P. Curtin

This is the ideal beginning darkroom guide. Easy to follow and fully illustrated each step of the way. Includes information on: the equipment you'll need, set-up, making proof sheets and much more! $17.95 list, 8½x11, 90p, hundreds of photos, order no. 1093.

Wedding Photographer's Handbook

Robert and Sheila Hurth

A complete step-by-step guide to succeeding in the world of wedding photography. Packed with shooting tips, equipment lists, must-get photo lists, business strategies, and much more! $24.95 list, 8½x11, 176p, index, b&w and color photos, diagrams, order no. 1485.

Lighting for People Photography, 2nd ed.

Stephen Crain

The up-to-date guide to lighting. Includes: set-ups, equipment information, strobe and natural lighting, and much more! Features diagrams, illustrations, and exercises for practicing the techniques discussed in each chapter. $29.95 list, 8½x11, 120p, b&w and color photos, glossary, index, order no. 1296.

Outdoor and Location Portrait Photography

Jeff Smith

Learn how to work with natural light, select locations, and make clients look their best. Step-by-step discussions and helpful illustrations teach you the techniques you need to shoot outdoor portraits like a pro! $29.95 list, 8½x11, 128p, b&w and color photos, index, order no. 1632.

Make Money with Your Camera

David Arndt

Learn everything you need to know in order to make money in photography! David Arndt shows how to take highly marketable pictures, then promote, price and sell them. Includes all major fields of photography. $29.95 list, 8½x11, 120p, 100 b&w photos, index, order no. 1639.

Guide to International Photographic Competitions

Dr. Charles Benton

Remove the mystery from international competitions with all the information you need to select competitions, enter your work, and use your results for continued improvement and further success! $29.95 list, 8½x11, 120p, b&w photos, index, appendices, order no. 1642.

Freelance Photographer's Handbook

Cliff & Nancy Hollenbeck

Whether you want to be a freelance photographer or need tips to improve your current freelance business, this volume is packed with ideas for creating and maintaining a successful freelance business. $29.95 list, 8½x11, 107p, 100 b&w and color photos, index, glossary, order no. 1633.

Infrared Landscape Photography

Todd Damiano

Landscapes shot with infrared can become breathtaking and ghostly images. The author analyzes over fifty of his most compelling photographs to teach you the techniques you need to capture landscapes with infrared. $29.95 list, 8½x11, 120p, b&w photos, index, order no. 1636.

Wedding Photography: Creative Techniques for Lighting and Posing
Rick Ferro

Creative techniques for lighting and posing wedding portraits that will set your work apart from the competition. Covers every phase of wedding photography. $29.95 list, 8½x11, 128p, b&w and color photos, index, order no. 1649.

Professional Secrets of Advertising Photography
Paul Markow

No-nonsense information for those interested in the business of advertising photography. Includes: how to catch the attention of art directors, make the best bid, and produce the high-quality images your clients demand. $29.95 list, 8½x11, 128p, 80 photos, index, order no. 1638.

Lighting Techniques for Photographers
Norm Kerr

This book teaches you to predict the effects of light in the final image. It covers the interplay of light qualities, as well as color compensation and manipulation of light and shadow. $29.95 list, 8½x11, 120p, 150+ color and b&w photos, index, order no. 1564.

Infrared Photography Handbook
Laurie White

Covers black and white infrared photography: focus, lenses, film loading, film speed rating, batch testing, paper stocks, and filters. Black & white photos illustrate how IR film reacts. $29.95 list, 8½x11, 104p, 50 b&w photos, charts & diagrams, order no. 1419.

How to Shoot and Sell Sports Photography
David Arndt

A step-by-step guide for amateur photographers, photojournalism students and journalists seeking to develop the skills and knowledge necessary for success in the demanding field of sports photography. $29.95 list, 8½x11, 120p, 111 photos, index, order no. 1631.

How to Operate a Successful Photo Portrait Studio
John Giolas

Combines photographic techniques with practical business information to create a complete guide book for anyone interested in developing a portrait photography business (or improving an existing business). $29.95 list, 8½x11, 120p, 120 photos, index, order no. 1579.

Fashion Model Photography
Billy Pegram

For the photographer interested in shooting commercial model assignments, or working with models to create portfolios. Includes techniques for dramatic composition, posing, selection of clothing, and more! $29.95 list, 8½x11, 120p, 58 photos, index, order no. 1640.

Computer Photography Handbook
Rob Sheppard

Learn to make the most of your photographs using computer technology! From creating images with digital cameras, to scanning prints and negatives, to manipulating images, you'll learn all the basics of digital imaging. $29.95 list, 8½x11, 128p, 150+ photos, index, order no. 1560.

Achieving the Ultimate Image
Ernst Wildi

Ernst Wildi teaches the techniques required to take world class, technically flawless photos. Features: exposure, metering, the Zone System, composition, evaluating an image, and more! $29.95 list, 8½x11, 128p, 120 b&w and color photos, index, order no. 1628.

Black & White Portrait Photography
Helen Boursier

Make money with b&w portrait photography. Learn from top b&w shooters! Studio and location techniques, with tips on preparing your subjects, selecting settings and wardrobe, lab techniques, and more! $29.95 list, 8½x11, 128p, 130+ photos, index, order no. 1626

The Beginner's Guide to Pinhole Photography
Jim Shull

Take pictures with a camera you make from stuff you have around the house. Develop and print the results at home! Pinhole photography is fun, inexpensive, educational and challenging. $17.95 list, 8½x11, 80p, 55 photos, charts & diagrams, order no. 1578.

Stock Photography
Ulrike Welsh

This book provides an inside look at the business of stock photography. Explore photographic techniques and business methods that will lead to success shooting stock photos — creating both excellent images and business opportunities. $29.95 list, 8½x11, 120p, 58 photos, index, order no. 1634.

Profitable Portrait Photography

Roger Berg

A step-by-step guide to making money in portrait photography. Combines information on portrait photography with detailed business plans to form a comprehensive manual for starting or improving your business. $29.95 list, 8½x11, 104p, 100 photos, index, order no. 1570

Professional Secrets for Photographing Children

Douglas Allen Box

Covers every aspect of photographing children on location and in the studio. Prepare children and parents for the shoot, select the right clothes capture a child's personality, and shoot story book themes. $29.95 list, 8½x11, 128p, 74 photos, index, order no. 1635.

Telephoto Lens Photography

Rob Sheppard

A complete guide for telephoto lenses. Shows you how to take great wildlife photos, portraits, sports and action shots, travel pics, and much more! Features over 100 photographic examples. $17.95 list, 8½x11, 112p, b&w and color photos, index, glossary, appendices, order no. 1606.

Restoring Classic & Collectible Cameras
(Pre-1945)

Thomas Tomosy

Step-by-step instructions show how to restore a classic or vintage camera. Repair mechanical and cosmetic elements to restore your valuable collectibles. $34.95 list, 8½x11, 128p, b&w photos and illus., glossary, index, order no. 1613.

Handcoloring Photographs Step-by-Step

Sandra Laird & Carey Chambers

Learn to handcolor photographs step-by-step with the new standard in handcoloring reference books. Covers a variety of coloring media and techniques with plenty of colorful photographic examples. $29.95 list, 8½x11, 112p, 100+ color and b&w photos, order no. 1543.

Special Effects Photography Handbook

Elinor Stecker-Orel

Create magic on film with special effects! Little or no additional equipment required, use things you probably have around the house. Step-by-step instructions guide you through each effect. $29.95 list, 8½x11, 112p, 80+ color and b&w photos, index, glossary, order no. 1614.

McBroom's Camera Bluebook, 6th ed.

Mike McBroom

Comprehensive and fully illustrated, with price information on: 35mm, digital, APS, underwater, medium & large format cameras, exposure meters, strobes and accessories. Pricing info based on equipment condition. A must for any camera buyer, dealer, or collector! $29.95 list, 8½x11, 336p, 275+ photos, order no. 1553.

Fine Art Portrait Photography

Oscar Lozoya

The author examines a selection of his best photographs, and provides detailed technical information about how he created each. Lighting diagrams accompany each photograph. $29.95 list, 8½x11, 128p, 58 photos, index, order no. 1630.

Family Portrait Photography

Helen Boursier

Learn from professionals how to operate a successful portrait studio. Includes: marketing family portraits, advertising, working with clients, posing, lighting, and selection of equipment. Includes images from a variety of top portrait shooters. $29.95 list, 8½x11, 120p, 123 photos, index, order no. 1629.

The Art of Infrared Photography, *4th Edition*

Joseph Paduano

A practical guide to the art of infrared photography. Tells what to expect and how to control results. Includes: anticipating effects, color infrared, digital infrared, using filters, focusing, developing, printing, handcoloring, toning, and more! $29.95 list, 8½x11, 112p, order no. 1052

Camcorder Tricks and Special Effects, *revised*

Michael Stavros

Kids and adults can create home videos and mini-masterpieces that audiences will love! Use materials from around the house to simulate an inferno, make subjects transform, create exotic locations, and more. Works with any camcorder. $17.95 list, 8½x11, 80p, order no. 1482.

The Art of Portrait Photography

Michael Grecco

Michael Grecco reveals the secrets behind his dramatic portraits which have appeared in magazines such as *Rolling Stone* and *Entertainment Weekly*. Includes: lighting, posing, creative development, and more! $29.95 list, 8½x11, 128p, order no. 1651.

Essential Skills for Nature Photography

Cub Kahn

Learn all the skills you need to capture landscapes, animals, flowers and the entire natural world on film. Includes: selecting equipment, choosing locations, evaluating compositions, filters, and much more! $29.95 list, 8½x11, 128p, order no. 1652.

Photographer's Guide to Polaroid Transfer

Christopher Grey

Step-by-step instructions make it easy to master Polaroid transfer and emulsion lift-off techniques and add new dimensions to your photographic imaging. Fully illustrated every step of the way to ensure good results the very first time! $29.95 list, 8½x11, 128p, order no. 1653.

Black & White Landscape Photography

John Collett and David Collett

Master the art of b&w landscape photography. Includes: selecting equipment (cameras, lenses, filters, etc.) for landscape photography, shooting in the field, using the Zone System, and printing your images for professional results. $29.95 list, 8½x11, 128p, order no. 1654.

Wedding Photojournalism

Andy Marcus

Learn the art of creating dramatic unposed wedding portraits. Working through the wedding from start to finish you'll learn where to be, what to look for and how to capture it on film. A hot technique for contemporary wedding albums! $29.95 list, 8½x11, 128p, order no. 1656.

Studio Portrait Photography of Children and Babies

Marilyn Sholin

Learn to work with the youngest portrait clients to create images that will be treasured for years to come. Includes tips for working with kids at every developmental stage, from infant to pre-schooler. Features: lighting, posing and much more! $29.95 list, 8½x11, 128p, order no. 1657.

Professional Secrets of Wedding Photography

Douglas Allen Box

Over fifty top-quality portraits are individually analyzed to teach you the art of professional wedding portraiture. Lighting diagrams, posing information and technical specs are included for every image. $29.95 list, 8½x11, 128p, order no. 1658.

Photographer's Guide to Shooting Model & Actor Portfolios

CJ Elfont, Edna Elfont and Alan Lowy

Learn to create outstanding images for actors and models looking for work in fashion, theater, television, or the big screen. Includes the business, photographic and professional information you need to succeed! $29.95 list, 8½x11, 128p, order no. 1659.

Photo Retouching with Adobe® Photoshop®

Gwen Lute

Designed for photographers, this manual teaches every phase of the process, from scanning to final output. Learn to restore damaged photos, correct imperfections, create realistic composite images and correct for dazzling color. $29.95 list, 8½x11, 120p, order no. 1660.

Creative Lighting Techniques for Studio Photographers

Dave Montizambert

Master studio lighting and gain complete creative control over your images. Whether you are shooting portraits, cars, table-top or any other subject, Dave Montizambert teaches you the skills you need to confidently create with light. $29.95 list, 8½x11, 120p, order no. 1666.

Storytelling Wedding Photography

Barbara Box

Barbara and her husband shoot as a team at weddings. Here, she shows you how to create outstanding candids (which are her specialty), and combine them with formal portraits (her husband's specialty) to create a unique wedding album. $29.95 list, 8½x11, 128p, order no. 1667.

Fine Art Children's Photography

Doris Carol Doyle and Ian Doyle

Learn to create fine art portraits of children in black & white. Included is information on: posing, lighting for studio portraits, shooting on location, clothing selection, working with kids and parents, and much more! $29.95 list, 8½x11, 128p, order no. 1668.

Infrared Portrait Photography

Richard Beitzel

Discover the unique beauty of infrared portraits, and learn to create them yourself. Included is information on: shooting with infrared, selecting subjects and settings, filtration, lighting, and much more! $29.95 list, 8½x11, 128p, order no. 1669.

Black & White Photography for 35mm

Richard Mizdal

A guide to shooting and darkroom techniques! Perfect for beginning or intermediate photographers who wants to improve their skills. Features helpful illustrations and exercises to make every concept clear and easy to follow. $29.95 list, 8½x11, 128p, order no. 1670.

Secrets of Successful Aerial Photography

Richard Eller

Learn how to plan for every aspect of a shoot and take the best possible images from the air. Discover how to control camera movement, compensate for environmental conditions and compose outstanding aerial images. $29.95 list, 8½x11, 120p, order no. 1679.

Macro and Close-up Photography Handbook

Stan Sholik

Learn to get close and capture breathtaking images of small subjects – flowers, stamps, jewelry, insects, etc. Designed with the 35mm shooter in mind, this is a comprehensive manual full of step-by-step techniques. $29.95 list, 8½x11, 120p, order no. 1686.

Outdoor and Survival Skills for Nature Photographers

Ralph LaPlant and Amy Sharpe

An essential guide for photographing outdoors. Learn all the skills you need to have a safe and productive shoot – from selecting equipment, to finding subjects, to preventing (or dealing with) injury and accidents. $17.95 list, 8½x11, 80p, order no. 1678.

Art and Science of Butterfly Photography

William Folsom

Learn to understand and predict butterfly behavior (including feeding, mating and migrational patterns), when to photograph them and even how to lure butterflies. Then discover the photographic techniques for capturing breathtaking images of these colorful creatures. $29.95 list, 8½x11, 120p, order no. 1680.

Infrared Wedding Photography

Patrick Rice, Barbara Rice & Travis Hill

Step-by-step techniques for adding the dreamy look of black & white infrared to your wedding portraiture. Capture the fantasy of the wedding with unique ethereal portraits your clients will love! $29.95 list, 8½x11, 128p, order no. 1681.

Practical Manual of Captive Animal Photography

Michael Havelin

Learn the environmental and preservational advantages of photographing animals in captivity – as well as how to take dazzling, natural-looking photos of captive subjects (in zoos, preserves, aquariums, etc.). $29.95 list, 8½x11, 120p, order no. 1683.

Composition Techniques from a Master Photographer

Ernst Wildi

In photography, composition can make the difference between dull and dazzling. Master photographer Ernst Wildi teaches you his techniques for evaluating subjects and composing powerful images. $29.95 list, 8½x11, 128p, order no. 1685.